MW01041104

Shaping Stone

Volume One

The Art of Carving Soapstone

By
Stephen C Norton

A NorthwindInk Book

Published by Stephen Norton at NorthwindInk

Copyright © Stephen C Norton 2011

All rights reserved. No part of this book may be reproduced or transmitted in any form or by any means, electronic or mechanical, including photocopying, recording, or by any information storage and retrieval system, without written permission from the author, except for the inclusion of brief quotations in a review.

ISBN: 978-0-9867556-8-2 paperback book
ISBN: 978-1-927343-00-5 .epub
ISBN: 978-1-927343-01-2 .mobi
ISBN: 978-1-927343-02-9 .lrf
ISBN: 978-1-927343-03-6 .pdb
ISBN: 978-1-927343-04-3 .pdf
ISBN: 978-1-927343-05-0 .rtf
ISBN: 978-1-927343-06-7 .txt
ISBN: 978-1-927343-07-4 .html

NorthwindInk Edition, Smashwords Edition License Notes
This book is licensed for your personal use and enjoyment only. Please do not copy or reproduce. Thank you for respecting the hard work of this author.

Other Editions Available
This book is also available in all e-book formats at
www.StephenCNorton.com

Library and Archives Canada Cataloguing in Publication

Norton, Stephen C.
 Shaping stone, volume one : the art of carving soapstone / by Stephen C Norton.

Issued also in electronic formats.
ISBN 978-0-9867556-8-2

 1. Soapstone carving. I. Title.

NK6058.N67 2011 736'.5 C2011-906887-7

for Gail

Disclaimer

The purpose of this book is to provide information, educate and entertain. Whilst every care has been taken in preparing the information contained in this book, neither the author nor the publisher guarantees the accuracy or currency of the content. By using this book, you are agreeing to the following conditions.

Neither the author nor the publisher can be held responsible for any errors or omissions and accept no liability whatsoever for any loss or damage howsoever arising from, or alleged to have been caused, directly or indirectly, by the use of this book or its contents. The author and the publisher reserve the right to remove or alter content within this book at any time without notice. Use of this book and its content is entirely at your own risk.

You expressly acknowledge that neither the author nor the publisher has any control over, or responsibility for, the content or privacy practices of any Internet site listed within this book. These sites are provided to you as a convenience and the inclusion of any site link does not in any way imply endorsement by the author or the publisher.

All content within this book and all services provided or described within it are provided "as is", with no guarantees of completeness, accuracy or timeliness, and without representations, warranties or other contractual terms of any kind, express or implied. All services and offerings described are subject to change without notice.

Books by the Author

Non-Fiction

Breaking Glass - Stained Glass Art and Design

An introduction to creating stained glass art, including tools, safety, materials, design, techniques and assembly.

Shaping Stone Vol I - The Art of Soapstone Carving

An introduction to the art of soapstone carving, including tools, safety, materials, design, techniques and finishing.

Zero Cost Self Publishing

A complete guide to self publishing your book in both paperback and multiple eBook formats, distributing to global markets, collecting royalties and not spending a dime.

Fiction

The Marseille Scrolls

The First Jeanne-Marie DeNord Book

2009: a cache of 1st century scrolls is discovered in Southern France. Jeanne-Marie, the archeological team translator, realizes that some of the scrolls are a woman's journal, telling a tale disturbingly different from known records. Jeanne hunts for answers, but finds only questions. She better find answers soon, for others intend to bury the scrolls for another 2,000 years, and maybe Jeanne too.

A Tapestry of Words and Demons

A book of poetry, thoughts, images and demons, from the early years.

Songs of Words and Demons

A book of poetry, thoughts, images, philosophies and demons, from the middle years.

Demon Dreams

A compilation of poetry.

Available in paperback and eBook formats.
For further information, please visit:

www.StephenCNorton.com

About the Author

Stephen started his career as a marine biologist, later switched to managing computer support and development teams and is now a full time author, artist and publisher. He lives on the West Coast of Canada with his wife and one crazy cat. He has five books currently available in both paperback and e-book formats, and has at least five more planned for the next few years. An artist for most of his life, he's worked in many mediums, from oil painting to blown glass. For the last 15 years he's focused on creating stained glass art and carving soapstone sculptures.

He can be contacted via his personal web site, which also provides links to all sites selling his books, including CreateSpace, Amazon, Smashwords, Barnes & Noble, Apple iTunes, Kobo and other resellers, at:

<div align="center">www.StephenCNorton.com</div>

You may also purchase his books via his author pages:
on Amazon:
<div align="center">www.amazon.com/author/stephencnorton</div>

on Smashwords:
<div align="center">www.smashwords.com/profile/view/northwind</div>

He has several books published, including a novel, introductory books on both Soapstone Carving and Stained Glass Art, a how-to guide to publishing and three poetry books. He is currently working on a sequel to The Marseille Scrolls, continuing the tales of Jeanne Marie deNord, as well as a book on advanced Soapstone techniques.

He is the founder and CEO of his own publishing company, Northwind Ink, which specializes in publishing and distributing soft-cover and e-books for new authors. Books published by Northwind Ink include novels, memoirs, 'how-to' books and poetry. Northwind Ink's services are available at:

<div align="center">www.NorthwindInk.com</div>

<div align="center">or email to: publish@northwindink.com</div>

Table of Contents

Chapter 1 - Introduction

Whenever I display my work, I watch the people as they inspect the sculpture. Almost without exception, people are impelled to touch the stone, to stroke it with their fingertips. They are always surprised and fascinated by the silky texture, the smoothness and warmth of highly polished soapstone. Soapstone is almost unique in that fascination. Unlike metal or ceramic, soapstone calls out to the viewer, asking to be touched.

Soapstone can be found all over the world, and has been used by many cultures throughout history, from ancient Egypt, to India, China and the far North. Soapstone artifacts have been found which date as far back as 5,000 BC. Today though, much of the world most commonly associates soapstone with the peoples of the North, once referred to as Eskimo, now more properly known as Inuit, Yupik and Aleut. Historically, these peoples used soapstone for many things, including dishes, bowls, cooking utensils, and, the most recognized, for carving and sculpting. Common motifs include seals, bears, walrus and other sea life, and also images of mythical or mystical beings, their creatures of belief and religion. Hand carved, using bone tools, sanded smooth using sand and soapstone dust, these carvings have evoked the North for centuries. When working with soapstone, I continually feel that almost spiritual aura that surrounds soapstone and its history. To work in soapstone today, one must also respect the culture and beliefs of those who first worked with the stone.

Today, while soapstone is still used for the old purposes, it is also now used for fancy kitchen counters and table-tops, fireplaces, floor tiles, ovens and other, more utilitarian purposes. On the artistic side, the original native artists have been joined by many non-native artists, like me, who have adopted the medium. The tools have changed from bone and stone to steel, hand work pushed aside by powered tools and machines. While the large volume productions do undeniably keep the beauty of the stone, I believe the industrial uses have lost touch with that spiritual essence of the stone. It's up to today's artists to maintain the more spiritual side of soapstone carving, to keep us in touch with the beauty of a carved image, rather than the more materialistic pride in a kitchen counter-top.

Unlike most minerals today, which are blasted away from their deposits, soapstone, like the harder marble, is actually carved from the mountainside. Pilot holes are drilled around a large chunk of stone. Diamond grit chains are then threaded through the pilot holes, connected to a set of flywheels, and then the chain grinds a channel through the stone. In larger operations, huge chassis-mounted diamond-toothed chain saws carve channels in the rock face, cutting away large masses of stone. Once the block is freed from the mountainside, it is pushed over onto a sand or earthen bed. As it falls onto the bed it tends to break into smaller pieces along the natural fault lines. Larger or unbroken pieces are sold off for industrial uses, smaller pieces become medium for soapstone carvers. I say smaller pieces, but even the small pieces can weigh a few hundred pounds. Carvers like myself usually work with pieces in the ten to fifty pound range.

Having fallen in love with soapstone, and having carved for many years, I started giving introductory courses at the local collective which carries my artwork, the Coast Collective in Victoria, British Columbia, on the Canadian West Coast. After giving a few well received courses to enthusiastic and talented novices, I decided to write this book to introduce others to the beauty that is soapstone, to show them, and you, how to carve soapstone for yourself. Like my introductory course, this book shows you how to take a ragged block of uninteresting

and dusty stone and turn it into a polished piece of art, something that calls to you, something you can touch, something you can be proud of. A piece of art that sings.

I've chosen to make this book pictorial rather than wordy. I'm a firm believer that a picture speaks a thousand words, so I've tried to show, and only talked enough to lead you into what the picture depicts. I've also chosen the size of the book so I can fit in lots of pictures, while keeping the pictures big enough that you can see the detail shown without needing a magnifying glass. At several points through-out the book, I point you to on-line videos so you can see the process in motion. Lastly, I've focused on giving you an overall introduction to soapstone carving, in order to keep the price of the book down so it's affordable. I've deliberately left the more advanced and exotic techniques for a later book, so you don't have to spend a great deal to begin this, your first journey into soapstone carving.

You don't have to be an expert to follow the steps in this book. You don't have to have any experience in carving, you simply need to have an interest, and a desire to create something. I will guide you through the process in eight easy-to-follow steps. I do suggest reading through the entire book before you start working on your stone, so you get a feel for the entire process. I always like to know what the next step is before I finish the step I'm on.

You only need a few tools, though I will show you other tools that can be useful. You can choose how much to invest and how many tools to buy. The basic tools can be purchased for twenty to forty dollars. The stone is reasonably easy to acquire and relatively inexpensive, usually no more than two to three dollars per pound, often less. Most rock shops carry an inventory of stones ranging from a pound or two and up. If there's no rock shop in your town, stone can be ordered on-line via the Internet. Safety issues are covered in the book, but soapstone is a very safe material to work with. Soapstone dust is basically talc, and talcum powder is commonly found in the home, usually in baby and body powder. Lastly, I've included photos of a variety of finished pieces, so you can get an idea of the range of images possible.

Sound interesting? Well, if you haven't already done so, buy the book. Pick up a few tools if you don't already have them at home. Go buy a chunk of soapstone, follow along with the book and let's start carving.

Chapter 2 - Tools and Workspace

When I work with soapstone, everything is done with hand tools – no power tools except…. Well, there are always exceptions aren't there? We'll get to them in a bit.

Before anything else, you require a work space. A table or workbench is fine. I use a table about seven foot long and three feet wide, plus a few shelves on the wall above for storage of tools and small stone pieces. A few lights scattered around, both fixed and movable, help illuminate the piece as I desire. However, if nothing like this is available, you can work on the kitchen table - just make sure you clean up well after each time you work.

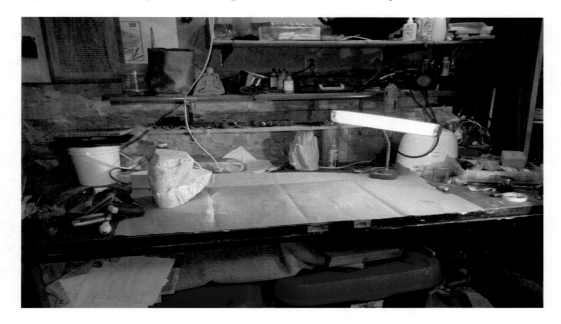

Now you've got a work space, what are the tools you need? Well, in a tight squeeze, you can do pretty much everything you need to do with soapstone with only two tools, and a bit of sandpaper.

Absolutely minimum tools required:
- ¼" flat chisel - long (for large pieces), or short handled (for 5-15 lb pieces)
- 6" or 8" coarse rasp
- Wet/dry sandpaper

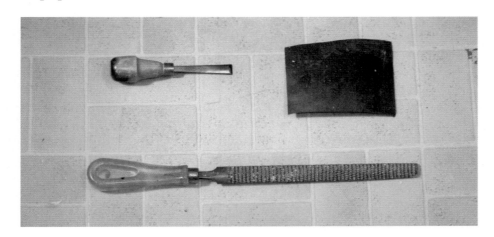

However, as we're not quite that limited, there are some other tools that will help the job move along. We'll do a quick review of the various tools here, then get into detailed descriptions of their use as we start to work on the stone. While you can buy small stones close to your required size and shape, it's usually more fun to buy a big chunk of stone and then cut it into the general shape you want. So, for that you need hand saws.

Hand saws.

Obviously the bigger saws with the large, nasty teeth are used for making big cuts quickly. The bigger the teeth, the faster the cutting goes, just be careful, sometimes the cut goes too fast and/or too far, which can change your whole game plan very quickly. Below are a straight edge saw (a), good for making flat cuts such as the bottom of your base piece, and below that is a hacksaw (b), with a very large-toothed blade, great for cutting through stone very quickly.

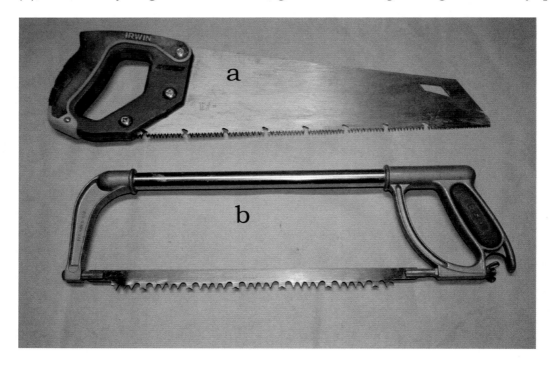

Because it allows you to turn the blade within the handle, the hacksaw is also useful for making cuts deeper than the depth of the blade, though it's not so good for making straight cuts such as a base, because the hacksaw blade does bend a little. These two saws allow you to shape the stone very quickly into a rough approximation of the shape you want. Remember, these saws cut deep and quick, so make sure you leave yourself some breathing room on the stone when the cut is finished. If you intend to remove 3 inches of stone, remove 2.5", maybe 2.75" with the saw, then use less drastic tools to fine up the cut. Because they cut so fast it is very easy to cut too far or too deep and ruin the shape of the stone for the intended image.

Saws (d) and (e) (below) are good for making finer cuts or for fine cutting in tight spots. Saw (c) is a specialty blade. It's not actually a saw blade at all, but a round rasp, capable of cutting in any direction. This makes it very useful for cutting round or odd-shaped holes and curves. The blade is held in place by the spring action of the handle, so it's very easy to pop the blade off, run it through a hole in the stone, pop the handle back on and cut with the saw inserted through a closed hole.

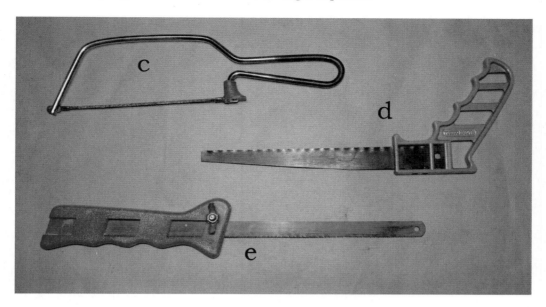

Rasps and Sureform Shapers

On the left below (a) is an 8" rasp, basically a very coarse file. Rasps allow you to remove relatively large amounts of stone quickly, but does leave deep grooves on the piece. Basically it's the tool for rough shaping after the sawing is done. I use an 8" half-round, coarse rasp, flat on one side and rounded on the other. This allows you do rough shaping and preliminary smoothing of the stone rapidly.

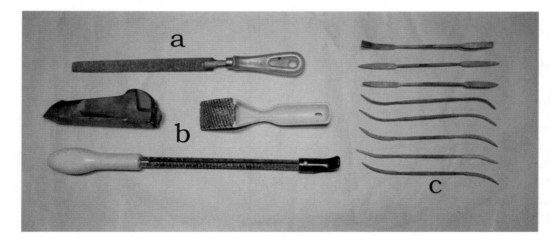

Below the rasp are three 'Sureform' tools (b). (Sureform is the trademark. You may find similar tools under different trademarks.) Basically they're shaped, sheet-metal rasps, but give a smoother cut than the regular rasp. The smoother cut means shallower grooves in the stone and less cleanup afterwards. The three shown are a flat, a wide curve and a full round.

On the right (c) and shown in more detail on the next page, are a set of specialty rasps in a range of different shapes. They're usually used for dealing with the inside of curves and holes, but can be used wherever you want.

Curved specialty rasps:

The set below includes a round, square, triangular, shallow curve, deep curve, very shallow curve, flat, and curved square. Their use is dictated by ease of access to the area being rasped, as they all have the same coarseness of rasp. I recommend using a glove when holding these tools, as they're double-ended, and the far end rests inside your palm when they're in use. A light glove, or even a heavier work glove, will protect your palms. If you're doing a piece with a lot of curves, groove or holes, these tools will get a lot of use.

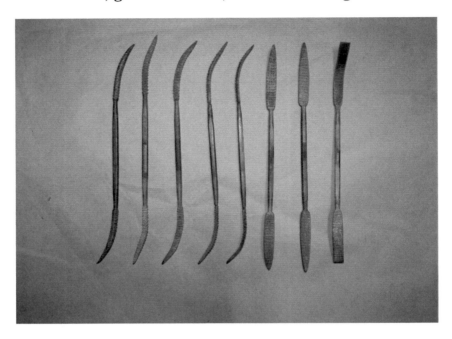

Chisels.

Once the rough shaping is dealt with you get into finer shaping and cutting. This is done with chisels. Having said that, there isn't any reason you can't use chisels for rough shaping as well, or rasps for more detailed shaping. It basically comes down to which tool you feel most comfortable with for any given task, on any given piece of stone, and that may vary from stone to stone and shape to shape.

Below are a variety of chisel sets, ranging from a ¼", to ½", ¾" and 1" widths. Chisel blade shapes are variable and can come in flat edge, slant edge, curved edge and shallow to deep 'V' blades. Some are even curved as well as shaped. Size and handles are also variable, ranging from long handled with a flat butt, usually intended to be hammer driven, to short, fat and stubby handled, usually intended to be hand driven, snuggling into the palm of your hand. I use the full range, depending on what I'm doing at the time, and sometimes depending on how I'm feeling at the time.

The width of the blade dictates how much material is removed with each sweep of the chisel. The shape of the blade, flat, curved, v-shaped or angled, dictates to some extent the shape of the cut made. The shape of the cut is also controlled by how you angle the chisel, while the depth of the cut is controlled by how much pressure you apply.

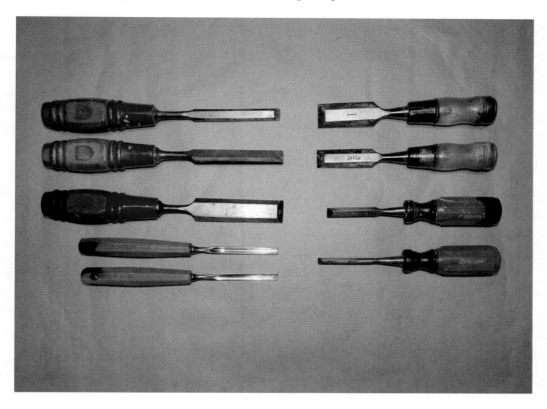

If I'm carving larger stones I tend to use the longer handled chisels. The tools shown above are for full hand use, or can even be held with one hand and tapped with a hammer. I don't use a hammer or mallet, as I find the sudden application of power to the chisel blade can do un-intended things, like going too deep, or causing the stone to splinter in unexpected directions or into unwanted shapes. I find that hand power gives much more control.

For smaller pieces, or more delicate work on larger pieces, I use the palm grip chisels, as shown below. The only real difference in palm grips is in the shape of the handle, and personal choice controls which handle shape feels most comfortable. The handle nestles into your palm, providing very precise control. However, the blades are correspondingly smaller allowing much finer work, but are not as useful for dealing with large areas of stone.

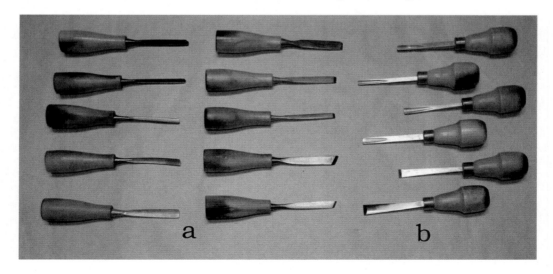

Most chisels have a flat side and an angled side, and each side works differently.

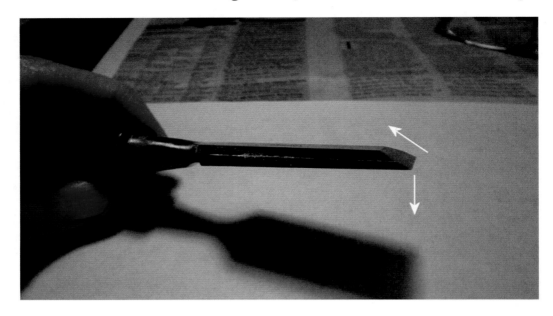

Carving with the flat side into the stone forces the carved bits of stone away from the cutting edge, and thus away from the stone. It does tend to push the cutting edge into the stone as you push forward, and in soft stone that can sometimes result in cuts which are deeper than intended. Turning the chisel to the other face, so that the angle on the blade is facing into the stone will tend to push the blade away from the stone. More control is needed to remove stone, but you're less likely to dig into the stone.

Files and Wet/Dry Sandpaper

Files, as shown below, (a) are used to fine shape surfaces, often curves, especially inside curves which are difficult to reach with a chisel. I normally use a medium, half-round file – flat on one side, curved on the other. This allows maximum flexibility with the same tool. I only have a couple of handles for my files and simply pop them off one file or rasp and onto the one I'm using. Files can be skipped entirely if desired, as coarse sandpaper can do the same task, but they have their place.

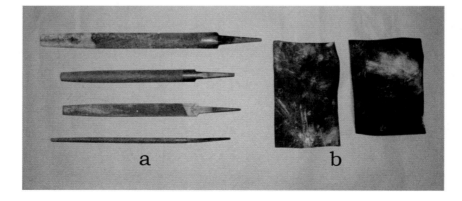

a b

Once the piece is shaped and fairly smooth, you start to fine smooth and polish the stone. This is done with sandpaper, above (b). Sandpaper comes in a variety of grits, which indicate how rough the sandpaper is, and thus how much stone the paper will remove with each

stroke. 60 grit is very coarse, and will take off more stone than a fine file. I usually start sanding with either 80 or 120 grit, working my way up through 180, 220, 320, 400, 600, 800, 1200, and 1500 grit. 1500 grit is a very fine sandpaper, intended for final polishing of hard stone. On some stone, especially the softer stones, you may not notice any appreciable difference between 600 and 1500 grit. In those cases, it's fine to stop at 600 or 800 grit.

Dry sandpaper produces a lot of relatively fine soapstone powder and dust, which is why I don't usually sand dry. With the one exception of using a dry sanding board to ensure my base surface is flat, I will only use wet sandpaper. Keeping both the stone surface and the sandpaper wet keeps the dust contained in the water. That keeps the dust out of your nose and throat, and off the furniture elsewhere in the house. Sandpaper for wet use is clearly marked 'Wet/Dry" and is usually a grey-blue-black color. Sandpaper intended to be used dry is usually brownish or light grey, and will quickly dissolve in water.

Power Drill.

Only use reversible, variable-speed power drills. They accept most of the common sized drill bits, hole drills and augers. When starting holes I use a power drill, and then expand and enlarge the hole with hand tools such as rasps and chisels. Reversible / variable speed drills are the best, making it easy to control the speed and thus the amount of dust spray and the depth of the cut. If the stone grabs the drill bit, you can reverse it to clear the hole without damaging the stone.

I use a variety of drill bits, ranging from standard bits to larger hole drills or augers for holes beyond the size of my drills (below, left). You can also get drill rasps, as shown below. You can use them with a reversible, variable speed drill, but like any power tool, they will produce a large amount of dust and throw it into the air. I don't use the drill rasps on soapstone.

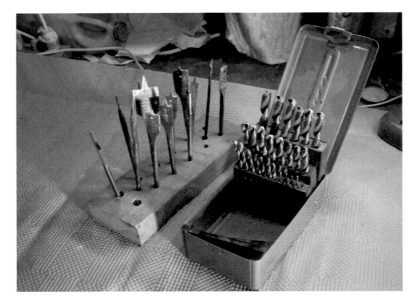

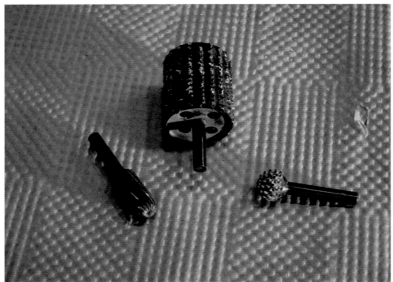

Pencil or Charcoal.

These are used for transferring your sketches onto the stone. Markers work, but you have to wet-clean and then dry the stone first. The dust on the stone will clog up the marker tip very quickly. I normally use charcoal or a very soft pencil – 3B or 4 B. Carpenter's pencils will work well too.

Newspaper.

Roll out a sheet or three of newspaper on your workbench, and do all your dry work on the paper. This allows you to keep the dust contained, and you can easily pick up the newspaper to dump the dust into a bucket as and when required to clear the work area.

Skill Saws or Power Saws.

DO NOT use them. They produce an incredible amount of very fine dust and spread it over a huge area! Use ONLY hand saws.

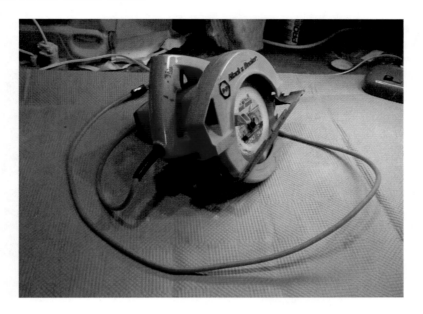

Sanding boards.

Basically a flat wooden board with a full sheet of sandpaper stapled to it. Used to clean up the flat of your base, ensuring the base is as flat and even as possible so the piece sits level and square when finished. I usually use regular 80 grit paper on the sanding board. This keeps the amount of dust down as it's quite coarse. As the bottom of the piece is never seen, it doesn't need to be finely polished. I make my own boards, as they're simply a full sheet of paper stapled to a flat cedar or pine board.

Dust bucket.

As you carve, you will produce both dust and small soapstone chips. These will fall onto the newspaper on your workbench and collect there. Every now and again, move the stone out of the way, lift the newspaper so the dust all falls into the centre crease, then dump the dust into a plastic bucket with a lid. A 10 liter bucket is fine. That way you can clear your work area of dust quickly and regularly. At the end of your work cycle, empty the bucket.

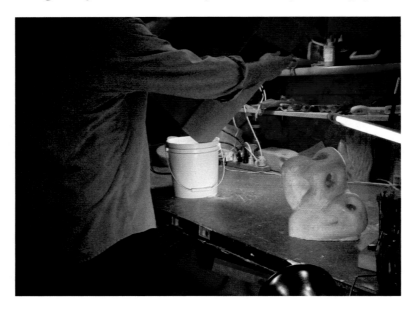

You can empty the bucket into your garbage, but I prefer to spread it around on the back lawn or garden and then turn on the sprinkler for a few minutes to wet the dust into the soil. It's harmless, plus it keeps down the slugs as they don't like to crawl across soapstone dust.

Catch Tray for wet sanding.

I use the lid of a large tub container. It provides a flat area with a raised lip to contain the water during wet sanding. As you will see, I use a lot of water during sanding and polishing.

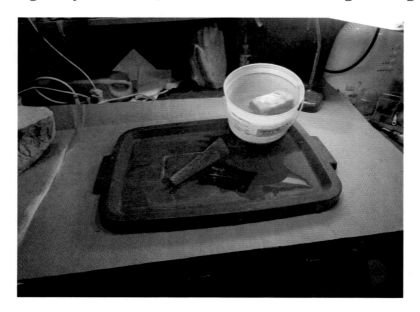

Sponge.

Used to wet out the piece in rough to get some indication of the grain, color and pattern of the stone, wash off the piece during sanding, and clean up the work bench and area when needed.

Water tub.

I use a 2 liter plastic ice cream tub container to hold the water during sanding and polishing. That's big enough to fit both my hand and sponge into easily.

Dremel tool

A Dremel tool or equivalent specialty item, usually used in conjunction with the extended snake, can be useful. While Dremel tools and their like are power tools, I do use them for some very specific tasks. The most usual task is to sign and date the piece, usually on the underside of the base. The only other times I've used the Dremel is to quickly apply a large number of small dimples in a piece, emulating feathers on birds, scales on dragons, skin folds on whales, and incising hieroglyphs into the stone. Dremel tools do produce dust. I sign and date pieces at my workbench. Small dimpling and incising is done outside, and I wear a dust mask while doing it, keeping the Dremel tool at a fairly low speed.

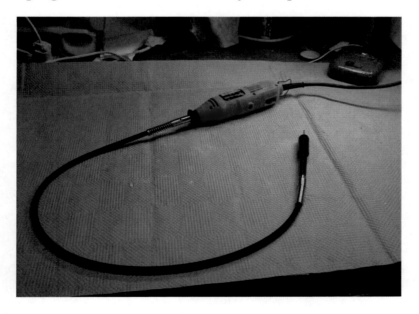

Gloves.

I use light duty gloves, more along the lines of gardening gloves than actual work gloves. They are enough to protect my skin from the files and rasps, but light enough to allow easy hand and finger movement.

I have tried the heavier work gloves (top of photo, below) but find their stiffness an annoyance, and the extra protection is usually not required, except as noted earlier when

holding the specialty rasps, and even there I find the garden glove (bottom of photo) to be sufficient.

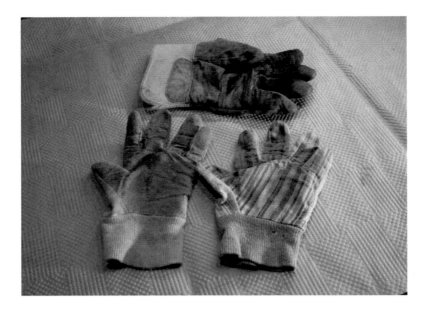

Air Filter.

I advise against using a fan in the workshop, as it simply spreads the dust around. What I do use though, is a filter / ionizer unit. The one I use has several speeds, sucks in at the front face and blows out through the top, having passed through several filters on the way. It also has the option to ionize the air which I was surprised to find does help. The ionization seems to help precipitate the dust out of the air.

Tung oil.

Once the piece is finished, I apply 2-3 coats of Tung Oil. This provides a slightly harder finish to protect the stone, leaves a shiny finish and brings out the color and pattern of the stone.

Lint free rags.

Used for applying the Tung Oil and first polish after each coat. If you don't use lint free, you run the risk of introducing lint fibres into the oil and will thus mar the stones finish.

Chamois.

Chamois or other very soft lint free cloth, used for the final high-gloss, finishing polish. Can also be used on intermediate polishes if you want, providing the Tung Oil is completely dry.

Lazy Susan

I find a Lazy Susan platform is handy during the oiling stage, as it allows you ready access to all sides of the stone without having to touch the stone. This is useful during oiling as it means you only touch the stone with the oiled, lint free cloth. I made my Lazy Susan from an old swivel and a piece of board. Just make sure it's heavy-duty enough to bear the weight of the stone you're using.

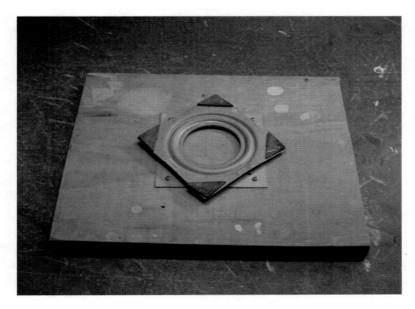

Music.

Without music, carving is a bit of a chore. With music, it's a wonderful exploration of your own imagination and musings. I use old rock & roll for early stages, something with a good beat, especially when rasping and sawing. Chiseling large chunks and gouging grooves and shoulders calls for hard rock (no pun intended). Delicate chiseling of fine detail calls for something a bit softer like blues and soft jazz. Sanding is repetitious but requires attention, so I play something soft, easy to listen to, soothing but melodious. It's your stone though, so it's your music. Make it fun.

Chapter 3 - Safety

Tools and Safety:

I was a Scout when I was young, and in those days it was quite acceptable for a Scout in uniform to wear a sheath-knife on his belt, even in public or on the street. One of the badges you could earn was wood carving, done with that sheath knife, which usually had a 5" or 6" blade on it. I still have my scout knife, though I don't use it for much any more.

So at scout camp, you'd end up with a group of eager Scouts, sitting around a camp fire, all industriously carving away with those fairly wicked knifes, chips flying in all directions. According to the scout leader, there was only one cardinal rule.

"Don't cut yourself, cut the guy sitting next to you!"

What he actually meant, after the laughter died down and the bandages were applied, (yes, you got a badge for First Aid too), was to keep the sharp edge of the knife pointed away from you. That way, when the blade slipped off the cut and ripped across the surface of the wood, there wouldn't be any fingers, hands, arms or legs in the way. That same rule applies to stone carving with hand tools. Chisels and rasps can cause some nasty surface injuries, so always push them away from you. The hand holding the stone steady should always be <u>behind</u> the path of the chisel, <u>NOT</u> in front of the blade.

Saws and chisels slice through stone quite readily. Sawing your hand, or burying the chisel blade in your palm, is painful, to say the least. A rasp tears off chunks of stone as it sweeps forward, and will tear off chunks of skin just as easily. Files aren't quite so nasty, but they can still grind off a layer or two of skin. Drills go through flesh about as well as they go through wood and stone. Holes in your hand are very hard to fill. Check what you're doing with the tool in your hand. As you use a tool, visualize the path it would take if it slipped off the stone. Make very sure that none of your body parts are on that pathway. In spite of what the scout master said, make sure no-one else's body parts are on that pathway either.

Benches:

Those scouts used to hold the wood they were working on in their laps, or on their knees. Needless to say, sometimes we earned even more First Aid badges, bandaging up those laps and knees.

When carving stone, place your piece on a bench or table, NOT your lap. Have your legs and knees tucked under the table if you're sitting, or stand beside the table leaning down over your work piece. Immobilize the stone by pressing it into the table, while you cut away with the other hand. Do NOT press it down into your knees or thighs.

Jigs and Clamps:

You can immobilize the stone in a clamp, or workbench clamp, but bear in mind the fact that soapstone is soft and clamps can exert a lot of pressure. Pressure can crush the stone and the jaws of a clamp can leave deep grooves and bruises on the stone itself. I never use a clamp. I will use one stone to help secure another. I often make quick and dirty, rough wooden jigs / forms / molds / rails / braces to help me trap the stone in the desired position and angle so I can work on it. Bigger pieces can be put in a plastic bucket to hold it steady, as you will see later. That doesn't harm the stone, as the only force being applied is the weight of the stone and the pressure of your hand holding it in place. An example V shaped jig is shown below. The stone slides up into the V and is thus held in that position.

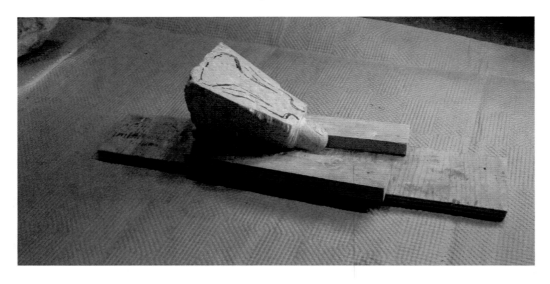

Eye and Face Protection:

Always protect your eyes and face. While I advise you to stay with hand tools only, if you choose to use power tools make sure you use eye, face and ear protection. When using hand tools, eye protection is still recommended, as chips can occasionally fly about, especially if you're using a chisel and banging on it with a soft hammer. I wear glasses anyway, so I rely on my glasses to protect my eyes while carving with hand tools. I don't normally use the ear muffs when working with sandstone, but you should protect your hearing if you're doing something loud. (Either that, or turn down the music a bit!)

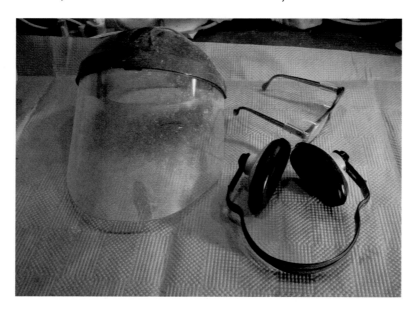

Dust:

Carving does produce some dust, but it's usually mostly large particle size. However, if you have ANY kind of respiratory issues then definitely use a mask. Masks of various types are available from most hardware stores, from simple paper and cloth mouth covers to high-end industrial filter packs. Pick one that's comfortable to wear and does the job you need.

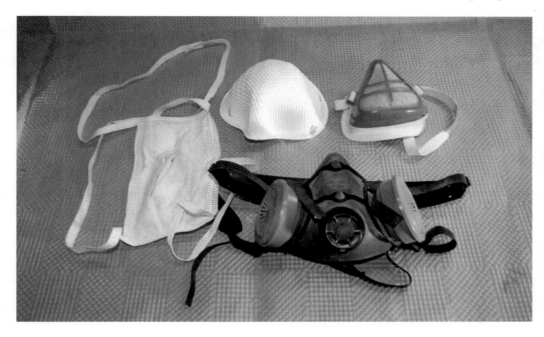

Rasps and files produce more dust than sharp chisels. Fine toothed saws produce more dust than coarse toothed saws. Don't put a fan near your work bench as you'll simply blow the dust around. As mentioned, I have a small ionizing filter fan on my workbench which I use if things get too dusty. It sucks in air from the side, runs the air through a series of filters and then blows it out upwards, so it doesn't pick up dust from the worktable and throw it around.

Don't use power tools like skill saws or power sanders/grinders. The amount of dust they produce is horrendous. I once used a skill saw to cut a piece of stone which was being stubborn. Once and only once. As soon as the blade touched the stone I, the deck I was standing on, and half the back yard, disappeared into a huge cloud of very fine dust. It took thirty minutes for the dust to settle, and a very long shower to get it all out of my hair. Luckily I was wearing a high-end filter mask at the time, but I could smell dust on the deck for days afterward. It took a good heavy rainstorm to finally settle it all out.

Dry sanding also produces a lot of dust, and the finer the sand paper, the finer the dust. For this reason, I do NOT dry sand. All my sanding and polishing is done in water, using wet / dry sandpaper. See the chapters on sanding and polishing for the details.

Soapstone dust is not dangerous in and of itself. Look it up on any geological materials web site. The dust from soapstone is mostly talc, with a varied sprinkling of other inert substances such as mica, amphibole, chlorite, pyroxene, magnesium silicate, serpentine, quartz, calcite and iron oxides. While talc is often used in body powers, such as talcum powder or baby powder, breathing significant amounts of <u>any</u> type of dust is definitely NOT recommended. Keep the dust levels down when you're working. If it bothers you at all, wear a mask. Have your workbench in the garage, or a separate room with a door that closes and a window that opens. Don't work next to the furnace with the house fan going. Your husband /

wife will have something to say about finding the entire upstairs coated in a fine dusting of white soapstone powder.

I have seen a couple of web sites which claim that soapstone contains asbestos, but those sites give no background information and cite no credentials. I have found many credentialed sites, government, geological and university sites, which state soapstone dust is talc, and advise no cautions other than basic dust control. There have been a couple of articles on older Inuit carvers with respiratory problems, but they had no dust control, and used the soapstone dust itself as a sanding and polishing agent (definitely not recommended). Given the similar statements from credentialed sites I have to go with the science and accept that soapstone dust is no worse than any other dust. Keep it minimized but don't get too concerned. Having said that though, don't breath any more dust than you have to, of any kind. If you're really concerned, ask your supplier to confirm that his soapstone is asbestos-free.

Stones and weight:

When you're dealing with big chunks of stone, with weights of 20, 30, 40 or more pounds, pay attention to the usual recommendations about heavy lifting. Pay attention to posture when lifting. Use your legs, not your back. If you have back issues, check with your doctor or only use smaller stones. I work in stones up to about 60 lbs. I have a two-wheeled dolly that I use for moving the stones around, and I only ever lift them once or twice - putting them in the trunk of my car, taking them out again, and when I put them on the bench to carve. For 60 pounders I will make a temporary ramp and drag them up and down instead of lifting them. Read the usual articles and recommendations on lifting and carrying heavy weights. You can't carve soapstone if you're laying flat on your back.

Chapter 4 - Sourcing the Stone

Before we get to selecting our rough masterpieces to be, we should discuss sourcing the raw stone. There are basically three sources of stone.

Go find a soapstone deposit and dig it up yourself. I've never done this myself. I did find a few soapstone deposit locations, but never got around to getting to them because they were quite a distance off the beaten track. That means you would need to carry the quarried soapstone quite a distance back to your vehicle. Carrying 40 or 50 lbs of stone any distance is not my idea of fun. The other issue is ownership of the land and therefore the stone. Finding the owner of the land is next to impossible, and that's required before you simply go in and take stone from the property. If you know a friend who has land with soapstone on it, by all means go for it. Otherwise, I suggest the next method.

Find a local store which sells soapstone, or is willing to bring it in for you. Lapidary stores, which sell stones and tools for jewelry making are a good bet. I'm lucky in having a store in town which carries an excellent selection of soapstone, along with specialty tools. This is your best source, as you can go down to the store and spend a hour or so manually selecting the individual stones you want. If you don't have a local store, you still have another option.

Buy stone off the Internet. When I started, I bought small stones from my local store. After some time I did some research and found a few sites on the Internet which offered what sounded like excellent stone at a price almost half the cost of my local store. The selection offered was amazing. After some emailing back and forth I ordered the minimum order of 300 pounds of stone, in various colors. I hadn't really wanted quite that much but..... Shipping costs immediately added almost half again the cost of the stone. Stone is heavy, and I was a bit surprised at just how much it cost to ship the stone sixty miles.

When I started working with the stone, I found that some was good, some was OK and some was full of 'inclusions'. Inclusions are areas of the stone which contain a much harder substance, such as quartz, which is impossible to carve with hand tools. The good stones were good. Solid stones, nice background color, nice patterns. The OK stone had OK colors, not much pattern but OK, but did tend to show a lot of very fine fracture lines. The fractures weren't severe, and didn't seem to affect the strength of the stone, but did tend to detract somewhat from the look of the finished piece. The poor stone was poorly colored, had little to no pattern, and was heavily laced with large, random quartz inclusions. The only way to deal with inclusions is to cut them out, or somehow incorporate the raw inclusion into your design. Trouble is, the inclusion will draw the eye and look like what it is, an unfinished piece of the stone, dramatically detracting from the finished piece. It looks like a very poor finishing job. I basically had to write off the fifty pound stone with all the inclusions. I can cut it up and do small pieces with it but it's not really very attractive because of the poor color and lack of patterning. To make things worse, inclusions will blunt your hand saws very quickly.... which is why I once tried using a skill saw!

In the end, I figured that my Internet purchase had ended up being more expensive by the pound than my local store, almost half again as much after taking shipping, lower quality stone and discarded stone into account. As a result, I don't buy off the Internet any more. That doesn't mean you can't, but if you do, be prepared to have to hunt around for a while, paying a higher price, until you can find a reliable source of good quality stone which makes

the other hassles worth while. The Internet vendor I tried did have some good stone, but it cost a lot to find out which of his stones were good and which were not. I could have re-ordered just the good stones, but shipping still pushed the price up, making it close enough to the local store price, that it just wasn't worth the extra hassle and potential for getting some lesser quality stones.

However, if you don't have a local store you can buy from, the Internet does become a viable source of stone. Just remember to add the cost of shipping on to the purchase price, and don't expect to always get the same quality of stone you would have hand selected.

Recommended source: Buy from your local if at all possible. Hand pick your stones so you only get exactly what you want and can reject the rest at no cost. Support your local vendors. It may look like you pay a bit more than Internet prices, but in the long run, you are much more likely to save money, plus avoid the frustration of getting lesser quality stones, or colors you don't really like. In addition, all the stone-store people I've dealt with have been very friendly, helpful, interested in working with me and are usually willing to give good discounts for purchases over 100 pounds.

So, now you have a source, how do you evaluate and select your stone? There's a few things to consider, as we'll see next.

Shaping Stone - The Art of Carving Soapstone

Chapter 5 - Seeing the Stone

Finished soapstone has a beautiful, glossy, almost glowing surface finish, combined with a deep lustrous color and interesting pattern. It makes you want to touch it, run your fingers over the surface, enjoy the caress of smooth, warm stone. It is almost sensuous. Trouble is, that's the end product of a fair amount of work, elbow grease and polish.

Raw, unfinished soapstone is a completely different beast. To the touch it's rough, sandy, dusty or powdery. To the eye it's usually dull, muddy colored, covered in a thin layer of grubby, off-white dust. The dust clings to your fingers, like a fine talcum powder, and makes your fingers slightly slippery.

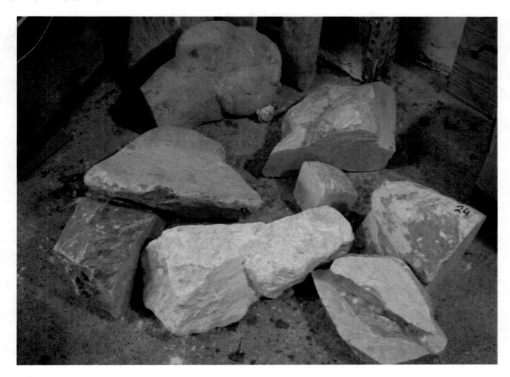

From that unappealing pile of stone chunks, the budding artist, or long-time expert, must see the potential of the finished piece. Here's how you do that.

Color, Grain and Pattern:

The first step is to identify the color and color pattern of the stone. Find a flat or cut surface on the stone. Wet a cloth or paper towel with a little water or light oil (baby oil is good) and wet out the surface of the stone. The stone will change quite dramatically.

You should now be able to get a reasonably good idea of the color of the stone. Is it a single, smooth color, mottled, striated, banded, multi-colored? Does the color have a texture or pattern? Are there darker or lighter spots, swirls or eddies? Is the color uniform or mixed, churned, agitated, like a milk shake just after the strawberry syrup has been added and stirred?

If there are several faces on the stone, wet them all. This will give you a good idea of how the color and pattern are distributed through-out the stone.

Dry Stone Wet Stone

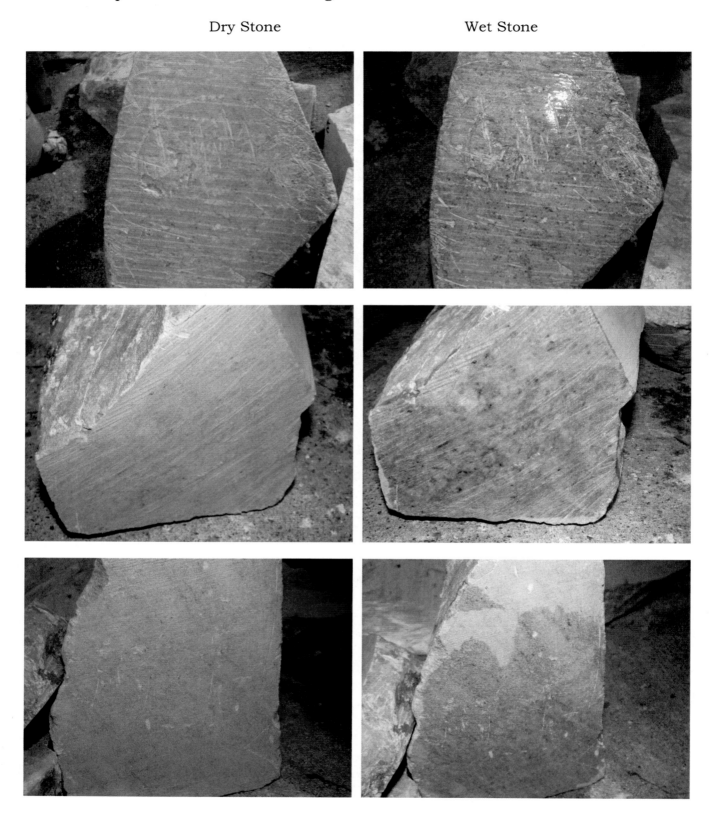

Soapstone is by far one of the more variable and variegated stones. It's common for example, to have a green-gray stone with a band of brown passing through it. A white stone

can have phases of other colors, sometimes one, sometimes several, scattered through it. This wild color variation is both a strength and a weakness of soapstone.

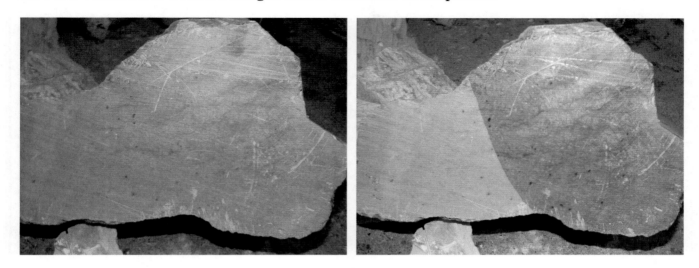

Carefully imposing your desired shape on the patterns of the stone can greatly enhance the finished piece. Conversely, finding a band of unwanted color creeping through the centre of your piece as you work can be disconcerting. That's when your creativity is required, to adapt the piece sufficiently enough to suggest you intended to use the color in that way.

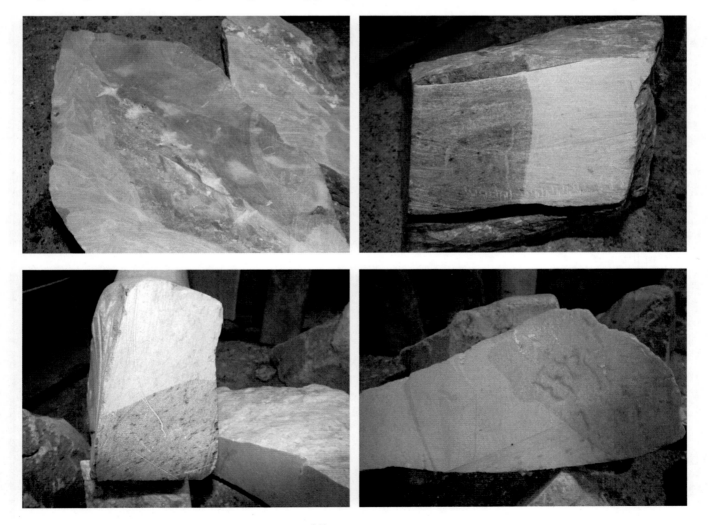

Very sharp color changes can also indicate a possible weakness, a potential cleavage face, in the stone. While usually not an issue in larger pieces, where the color change is spread across six or more inches in each dimension, smaller pieces with a hard color change down the centre are quite likely to crack or break along that color change. This applies especially to flatter pieces where the stone is thin in one direction across the color change. While I've never had a large piece crack at a color interface, I have had smaller pieces, say 3" x 3" x 2", separate along the color change line.

Happily, such hard, sharp color changes tend to be uncommon in stones found in the store. If the break is going to happen, it usually happens when the stone is first quarried or during the initial shipping. They are also easily seen when the raw stone is wetted out. While not necessarily a reason to reject a stone, a hard color change does suggest the work may be a little harder as you incorporate the color change into your design. The color change may also indicate a texture change, where one color is harder or softer than the other. Such texture changes can reflect in the final polish as harder stone takes on a more glossy finish than soft stone does.

Normal, reasonable quality soapstone should have a good color base with a good mix of alternate colors or shades distributed relatively evenly through-out the stone. All you have to do is pick the colors and patterns you want.

Hardness:

Once you've narrowed the selection of your stone based on color and pattern, you need to check on the stones hardness. While hardness is rarely a selection criteria, softness can be a reason to reject a particular stone.

Find that flat surface again. Drag your fingernail hard across the stone face. It will leave a mark. How deep the mark is will give you an indication of hardness. A deep groove indicates a soft stone. Very easy to carve, but only takes a moderate polish and shine. 'Carves like butter' is the term commonly applied. The finish of such a soft stone will be matte.

If your fingernail leaves a very faint, thin line, the stone is hard. Carving will require more time and effort, as will sanding and polishing. However, the hard stone will take on a very nice, bright, glossy finish and the colors will shine.

I've done pieces in both hard and soft stones, and achieved very satisfactory results with both. Don't expect to get a high gloss finish on a very soft stone though. I prefer stones that are about three quarters of the way to hard. Not quite so time consuming for sanding and polishing, but gives a nice glossy finish. Preferences are personal though, so try various stone types. One of my favorite pieces is a white sperm whale (Moby Dick) made from buttery white stone. There's a photo of this piece in the last chapter, showing the matte finish of soft stone, rather than the gloss of hard stone, but beautiful none-the-less.

If your fingernail leaves a mark which varies in depth, that means the stone has both soft and hard areas mixed together. I tend to reject these stones, as the finish will vary dramatically between areas, making the piece look bitty or unfinished. It can also mean you could end up with a soft spot in a crucial part of your piece, such as the fluke of a whales tail or the nose of your bear. Such texture differences can enhance your piece if you can arrange to reveal them in the right places, but you're at the mercy of the stone. Murphy's Law says that the soft 'imperfection' will most likely appear in the least desirable spot.

Some stones have a nice speckled pattern (left, below), and the speckles may be much harder, sometimes even gritty, when compared to the base stone. However, if these inclusions are small enough, they can be effectively ignored when carving. As they're distributed evenly through-out the stone, they can add character and enhance the finished piece quite nicely. Larger inclusions (below right, all the arrows) are much more difficult to deal with. These are inclusions of a much harder substance, in this case, quartz. They are so large, and so randomly scattered throughout the stone that they make the stone essentially useless. Generally, small granular inclusions like those on the left are acceptable. However, if the inclusions are larger, say 1/8" or larger, and scattered randomly and unevenly, I would reject the stone. The piece with all the inclusions shown was one of my Internet purchased stones.

 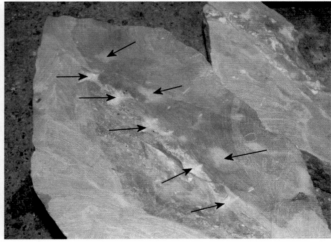

Very hard inclusions cannot be worked with hand tools, rather they must be worked around or simply cut out. Either work-around can drastically change your chosen shape, often resulting in a finished piece which looks damaged. Only accept inclusions of this type if you really, really love the stone for other reasons (color, pattern), intend on carving a free-form shape, and are willing to accept changing your shape as you are forced to excise the inclusions, or work around them in some way. Hand tools cannot work such inclusions, saws can't cut through them and chisels simply go blunt. The one stone I did have with such inclusions led me to try using my power saw to cut it into more usable pieces, with disastrous results.

Inclusions don't just come in the hard version though, they also come in soft versions, areas of stone which are much softer than the main stone. They may be soft, crumbly or fibrous. Like hard inclusions, soft inclusions are a good reason for rejecting a stone, however, they are a little easier to work around than the hard variety. If you're careful, the soft inclusion can be feathered into the main body of the stone. They will leave a visible change in the stone, and when finished, the soft area will have more of a matte finish than the harder stone around it. That may be OK if it's in the main body of the piece, and sometimes can even add a bit of texture and character. If the soft spot is on the edge of the piece though, it's a definite problem. A soft or crumbly edge will be much easier to damage, and usually leads to the piece appearing slightly damaged even when it's not. So, if you're really in love with the color and pattern of the stone, and the soft areas seem to be in the body of the stone and you think you can deal with that, go ahead and buy the stone. I've done a few pieces like that, simply because I started out with a stone I thought was good which, half-way through carving, turned out to be not so good. Mostly they can be dealt with, but if I have the choice, I will reject stones with soft inclusions just as I will reject a stone with hard inclusions. The stone we're going to work on here did turn out to have a few soft spots, but they blended into the piece quite well. Still pictures of the soft inclusions don't show at all well, but the video link below shows what a fibrous soft inclusion looks like, and gives an idea of how to work it.

Link to video: http://soapstone1.stephencnorton.com/home/chisel

Shape:

So, you've got the color and color pattern you want, you've checked the hardness and are happy with that, now you need to think about the shape. Some stores will carry several pieces of stone in each color mix, other stores may have a much more limited selection. You may have a choice of only one stone. If possible, it's desirable to have the shape of the raw stone generally match the shape you plan to carve, though it's not critical. It does mean less rock to cut away, therefore less work and less wastage. As soapstone is usually sold by the pound, the less rock you need to cut away, the less money you cut away.

It's nice to find a stone close to your desired shape, nice to minimize wastage, but don't get too hung up on that. I'll give you some options for using the cut away bits later on, and a larger bit can become a nice piece of art in itself. The shape of the stone is a 'nice to have', but the real key issue is the shape of the finished piece. What is it and how do you get there.

Chapter 6 - Getting There

When carving, I've found that there are four main pathways from the raw block of stone to the finished piece. Each has it's own issues.

Path 1: the Mystical Path

I'm a born skeptic, so the first time a sculptor told me he simply 'freed the shape' that was inside the stone, I regret to say my first reaction was..."what a bunch of malarkey!"

Now, years later and having carved a fair number of stones, I find myself asking the stone what it wants to be. It's quite common for me now, to simply start a new piece with no particular image in mind. As the stone smoothes out its rough edges and begins to round out, a shape will often simply emerge. Sometimes its something I might have expected. Sometimes it's a shape which I would never have considered. My favorite turned out to be an African woman's head, where the left side was the face of a pretty young woman, just beginning her adult life, say about 18 or 20 years old. The right side became the same woman at the end of her story, with time and experience shaping the face of a woman of perhaps 80. I had no part in selecting either image. My hands worked the stone and the image simply emerged. So, that's the Mystical pathway. Listen and let the stone itself guide you to an image.

Path 2: the Rational (or Planned) Path

Sometimes a stone speaks, other times it sits in silence. Sometimes you hear the stone, sometimes you don't, or you simply choose not to. Either way, you decide to impose a shape of your own choice onto the stone. Perhaps a quarter of my stones speak to me. For most of the rest I tend to find myself taking the Rational path. I impose a shape on the stone and work towards that end.

Selecting shapes is unique to each person. I use a number of methods. For free form, I imagine the shape, then sketch it out on paper from a number of angles - each side, front, back, top. The sketching helps me finalize the shape and get a clear image in my head. I then tape those sketches above the workbench for reference and start shaping the stone. Don't think you can sketch? Don't worry! The answer to that is Path 4.

For animals, or other 'real' shapes, I go through books and web pages, gathering a number of pictures of the animal from various angles and in various poses. Then I sketch out the figure in the pose I want and proceed as in free form. I do have a thing about real shapes though.

Viewers, those prospective buyers, look at your work with a very critical eye. They do say that everyone is a critic. Free-form shapes are easily accepted. They're either liked or not, but viewers rarely criticize that the shape is wrong. Animal shapes are a much tougher sell. Most people will look at a sculpted animal and feel slightly uneasy if it doesn't match their idea of what the animal should look like. Maybe the head is too big for the body, or a limb too short or too long. They might not even be able to tell you what it is that doesn't look right, but they will be able to tell you that the piece as a whole doesn't look quite right, not 'real'. If it doesn't look right to them, they won't buy it.

So, when I do animals, I take measurements, even if it's only measuring a few photographs. My sketches then incorporate the measurements, so I have a 'real' idea of how long a whale's fluke should be in proportion to their body size. I know where the fins really attach to the body, where the blow-hole is, relative to the head, mouth and eye. So, be careful when doing real-life images. You need to make them 'right'.

Once I get a well measured, well balanced series of sketches, sides, front, back, top, maybe body arched up, body arched down, I'll transfer my sketch onto the rough stone. To sketch on the stone I normally use a very soft pencil (2B or 4B). You can also use charcoal, or even a metal scribe to scratch into the stone. At this point the marks on the stone don't matter because they'll be removed during the roughing-in process. Once I'm happy with the sketch I've drawn on the stone, I'll start to rough cut the rock down to the general shape I want, using the larger, coarse-cutting hand saws and rasps.

Because I'm imposing a shape on the stone, and I want the shape to be fairly precise, I'll re-draw the sketch on the rock several times as I move closer to the final shape. Once the initial shaping is done, I'll only use pencil or charcoal on the stone, as these marks can be easily removed without changing the shape itself. If I continued to use the metal tool for the on-stone sketches I run the risk of noticeably changing the shape in order to remove the scratched in sketch.

The process continues in that way. Sketch the image on the stone, carve away stone to match the sketch, check the image, check the stone. Repeat as needed until you feel the stone is as close to the sketch as you want to go, then move into smoothing and polishing.

That's the Rational, or planned path. You impose a definite, pre-defined shape. What's next?

Path 3: Fate

Sometimes when you're on the rational path, you may find that the stone objects. Maybe it spoke to you earlier and you didn't hear or didn't listen. Some stones can get a bit touchy if you ignore them. This results in odd things happening. You'll make a saw cut, and find you went too far or too deep, and it's ruined the shape you were aiming for. Maybe you cut down the stone and found a soft spot right where the head was going to be. Maybe you drop a chisel on the stone, and that all-important front paw breaks off.

Now you have a choice. You can down-size your shape so it fits into the remaining stone, and carry on. You can listen to the stone, go where it wants to go, and carry on. You can set the stone aside for a few days or weeks and go work on another piece. Or, you can grossly exaggerate the departure from reality and make it obviously impressionistic. Given what his works sell for, Picasso can't really be wrong.

Any of these choices is acceptable, but all require you accept that the stone and your planned image aren't going to mesh, and work with what you've got. Don't get too concerned. Many Fate pieces look just as good as Rational pieces, and you can always pretend that the result was exactly as you'd planned all along. No-one will know except you and the stone.

Path 4: Chaos Method

Lastly, there's what I used to call pot luck. I described it to a friend and he renamed it the Chaos Method, which I like much better (thanks, Gerry). Sometimes you sit and stare at a stone and absolutely nothing happens. The stone is 'stone silent'. Your imagination has taken a long lunch break, and setting the stone aside for a few weeks simply means you've still got the same problem next month. So, you round out the edges, smooth the shoulders, accentuate the grooves, and still nothing happens. Now what?

The answer is simple. Start hacking. Or drilling. Or sawing. Or rasping. Or do it all! Roll a dice. Drill that many holes in the piece. Take a drill, hole drill or auger and drill a big (or small) hole somewhere on the piece. Rasp down the rough spots, accentuate any existing dips, curves, hollows. Cut a curve into one side, or both sides. That's the Chaos Method. The piece documented in this book shows an implementation of the Chaos Method. (See, no sketching required!)

Somewhere along the line you'll begin to see something in the rock. Head in that direction. My favorite was a single hole at the top of a stone. After staring at that for a few days, and hesitantly removing a bit of stone here and there, it became an eye, then evolved slowly into a crow's head. That in turn led to cutting in wings, which quickly turned into long, sculpted leaves. The final piece was called Crows Head Tulip, which is on the cover of this book. It looked great, and sold on it's third showing. A small part of its evolution is shown in Chapter 17.

An alternative to what I've described above would be to cut the big stone into a few smaller pieces, then stare at the pieces for a while. Trouble is, that could lead to having traded one piece with no idea, to several smaller pieces and still with no ideas.

Those are the four methods, or approaches, to designing and carving a sculpture that I use. Let's step back now and see where we are.

So far you've picked your stone, the size, color, pattern, hardness and general starting shape. You've picked a path to follow and hopefully you have some sort of image or end result in mind. Better yet, something sketched out on paper! If not, we'll have to use the Chaos Method. Now we can begin. Next step.... Rough Shaping.

(Just before you start hacking, have you checked out Chapter 16, the section on documenting the journey?)

Chapter 7 - Rough Shaping

Rough shaping of the piece can start with any of several tools. If I don't have a shape in mind, I usually start with a rasp, smooth down the rough edges, round out the corners, accentuate the grooves. If I have a shape in mind, then I usually start with a pencil, sketch my image onto the stone, then grab a saw. Use the saw to cut the stone down to approximately the shape and size of the image you have in mind, then switch to rasp or chisel.

Using a Saw:

If I have a shape in mind, and it requires large pieces of the stone be removed, I usually start with a hand saw. Saws can be used with one hand, while the other hand holds the stone steady, or, on larger stones or stones held in position by other means, both hands can be used. Run the saw in long steady strokes, letting only the weight of the saw press the blade into the stone. If you apply additional pressure downwards on the saw you run the risk of having the saw blade bend slightly during each stroke, which results in a cut which has folds and texture. That's OK for rough shaping cuts, but not for cutting the base.

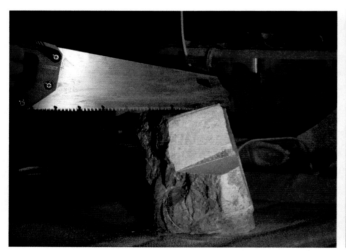 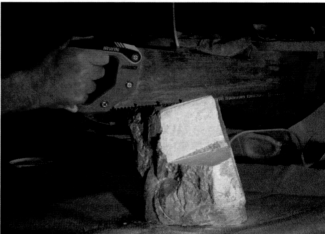

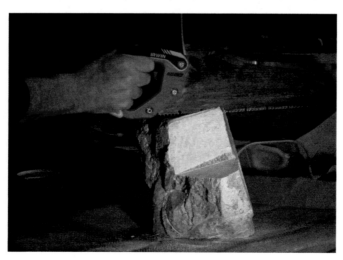

The hacksaw blade is used the same way, full, easy strokes, using the full length of the saw blade. The large teeth on the blade shown will cut more quickly, but will not give as flat a cut as the saw shown above. Again, applying downward pressure on the saw will cause the blade to bend slightly with each stroke. Because the hacksaw blade is fairly slim, applying a lot of pressure can even cause the blade to snap. For most cuts, the weight of the saw alone is sufficient for nice clean cuts.

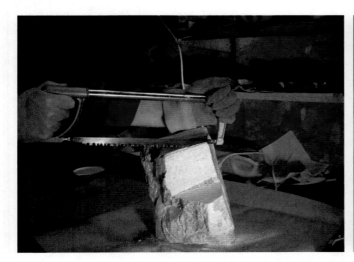
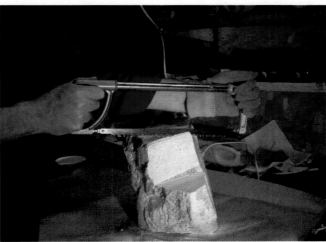

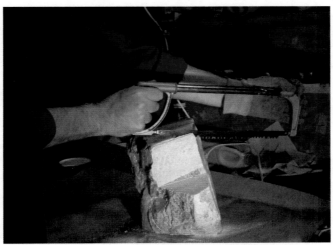

If the cut is deeper than the back support of the hacksaw allows, you can go deeper by turning the blade sideways. Loosen the wing nut at the end of the hacksaw. Pull or push the wing nut screw out of the handle until it can be turned. Turn it the way you want it, and then re-assemble the handle and blade.

This technique can also be adapted for cutting long holes inside the body of the stone. Use a drill to make a hole large enough to accept the hacksaw blade. Disassemble the hacksaw as shown. Feed the blade through the hole and then re-assembly it, so the blade remains inserted through the hole. You can now use the saw to cut a large hole or strip inside the piece. Using a saw this way speeds up the cutting, over gouging out the strip using a chisel, but does run the risk of cutting too much, too fast.

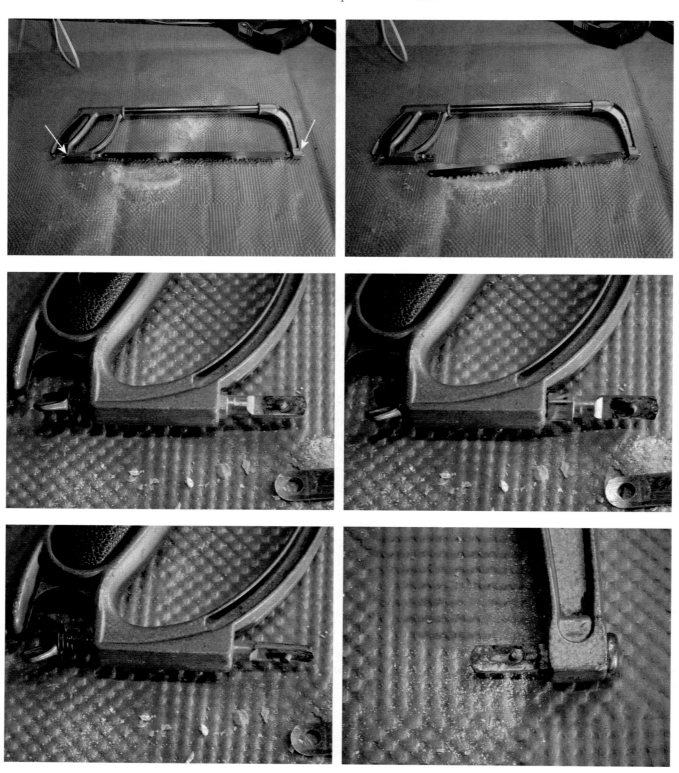

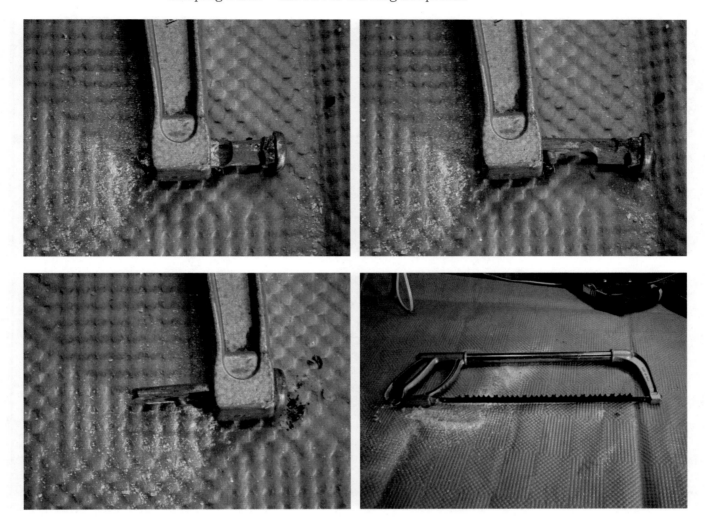

Once you've turned the blade sideways you can continue the cut with the handle off to the side, instead of above the cut.

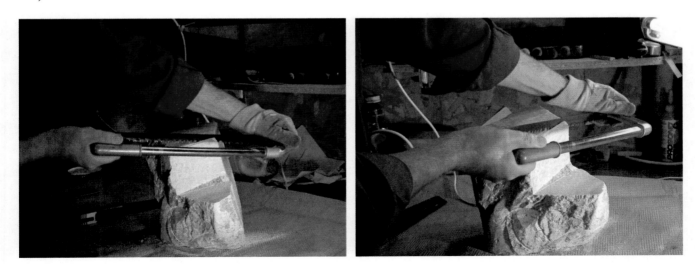

For cutting the base I use the saw with the more rigid blade, as this will give an almost flat cut. Remember to support the 'cut-off' piece of stone during the final cut strokes, otherwise the waste piece can break off at the last minute, leaving either a step of stone which must be removed, or a rough indent in the stone which can impact the image or shape of the base. Once completed, the cut surface can then be rough sanded completely flat with 80 or 120 grit paper, using a sanding board.

When you cut the base depends on how much stone you're planning on removing from the piece, and where you plan on removing it from. If you're only removing a small amount of stone, and the balance of the stone is unlikely to be affected, you can cut the base very early on in the carving process. If you're removing large amounts of stone, especially from one side or another, you will change the balance of the stone. In that case, it's better to remove the pieces of stone first, get the general shape of the stone the way you want it, and then cut the base. The angle of the base cut will be dictated by the balance and weight distribution of the stone. You always want to have the stone sit squarely and evenly on its base, without any wobbles.

If your piece is going to be heavier at the top than the bottom, or heavier on one side than the other, you need to either plan in a heavy base section as part of the original stone, or plan to sit the finished piece on a separate piece of stone which will act as the stabilizing base. Attaching one piece of stone to another is usually done with a combination of glue and pins. The finished piece should be stable and steady on its base. Pieces that wobble on their base will get knocked over and scratched or damaged.

Using a rasp:

Once the sawing is done, I switch to a coarse rasp to do the next step of shaping the piece. Hold the handle of the rasp with one hand, grasp the other end gently, probably best to have a work glove on that hand, and sweep the rasp back and forth across the piece. Use long strokes, using the entire length of the rasp, the same as the saw. The hand at the far end of the rasp acts to steady the rasp and keep the direction of movement steady. The hand on the handle provides the forward and backward movements. Both hands provide a light pressure pushing the rasp into the stone. The heavier the pressure the more stone removed with each stroke, but the more likely the rasp will jam or stop during a sweep. Using a rasp one-handed is possible, and often done, but it requires more wrist strength to hold it steady. The two handed stance is easier to maintain. Rasps work when moving in either direction, though the forward stroke tends to take off larger flakes than the backward stroke. Using a glove on the far end protects the skin on the hand, especially if you hit an inclusion or a rough spot and the rasp stops suddenly.

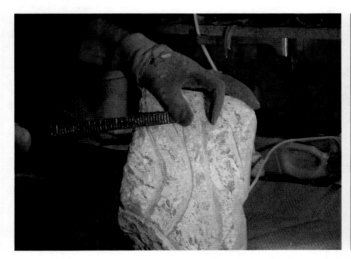 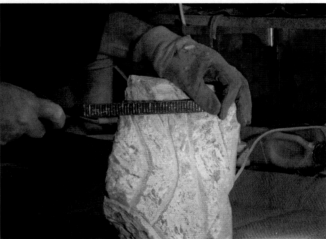

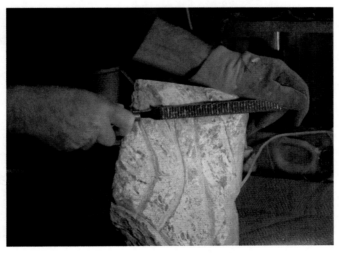

Sureform tools are used in exactly the same way as the rasp. The rasp is very coarse and tends to leave deep grooves in the stone. The Sureform is not as coarse and leaves a smoother surface behind, though it doesn't remove quite as much stone with each pass.

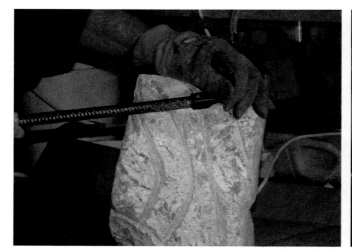 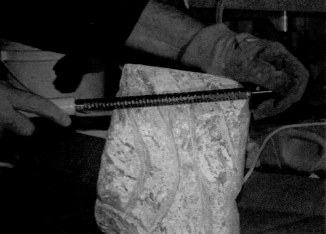

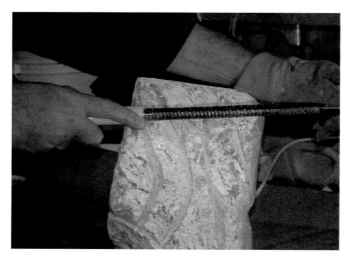

Link to video: *http://soapstone1.stephencnorton.com/home/rasps*

Large rasps are either flat or half-round, while Sureforms come in a variety of shapes and sizes. While the Sureforms are more expensive than rasps, the wider choice of shape and size does make them more useful. I have three Sureforms, and I use them all fairly regularly.

Using a Chisel:

If the piece is fairly small you can start working it with a chisel. You can also start with a chisel on a larger piece if you want, however, if the piece is of any size, saws and rasps will usually work better for the initial steps as they remove more stone faster.

Hold the chisel with the handle in the palm of your hand, forefinger along the top of the chisel blade. The hand provides the driving force, the finger provides the guide, pressing the blade into the stone. The higher the angle you hold the chisel, the more stone you will remove, but the more likely the chisel will jam. Too steep an angle forces the chisel to dig deep into the stone, until it reaches as depth and angle that stops the chisel from moving forward. I will usually angle the chisel to take off no more than $1/8^{th}$ of an inch of stone at a time. That removes a reasonable amount of stone on each sweep, while providing excellent control of the cut.

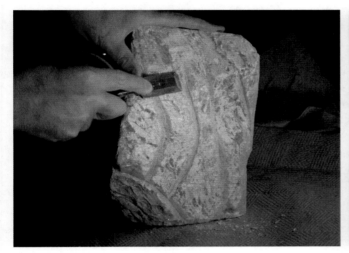 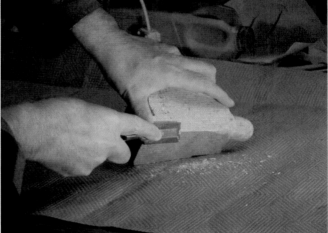

Link to video: *http://soapstone1.stephencnorton.com/home/chisel*

Like all tools, chisels come in a wide range of prices. If you're just starting out and need to buy chisels, I suggest staying on the inexpensive side. Most hardware stores sell three-piece sets of large handle chisels for around $10. These are fine for beginners, and while they don't hold an edge as well as the more expensive sets, they provide great practice for sharpening.

If you decide to buy a set of the palm chisels, again, most hardware stores carry beginner level sets in the $10 - $20 price range. There's really no reason to spend more than that until you decide to become a full-time sculptor. The beginner sets, combined with the occasional sharpening, will be fine for the first couple of years.

Regardless of the quality of the chisel you purchase, like any sharp tool, they will become dull or blunt with use. When the blade stops removing a nice clean wafer of stone, or requires more and more pressure and angle to remove stone, it needs to be sharpened. I sharpen my chisels using the 400 grit wet/dry sandpaper. It only takes a moment, and keeping your tools sharp makes them much easier and more enjoyable to use.

 Lay a piece of sandpaper flat on the workbench. Hold the chisel so that the angled edge of the blade is parallel to the work bench surface, with the blade just slightly razoring the surface of the sandpaper, and run the chisel back and forth across the sandpaper. Check the surface

of the angle. Your shiny new face should match the existing angle of the chisel. Once you're happy with the angled edge, turn the chisel over, hold it flat to the table surface and do the same on that side of the blade. The flat side will only need a few strokes.

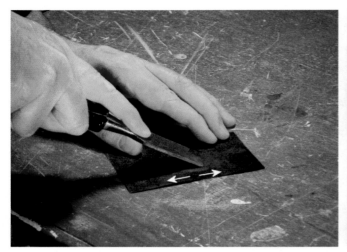 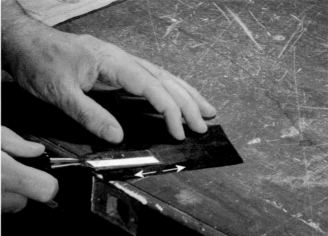

A gentle back and forth motion is all that's required, with the blade angled so that it's flat to the paper, just barely shaving the surface of the paper. You want the paper to sharpen the blade, rather than the blade shaving off the top layer of the paper.

The intent is to sharpen the edge without imposing any new or different angles to the chisel blade. If you've done it right, the chisel blade edge will be shiny, and cut cleanly. This will take a little practice to get just right, but you'll know when you've done it, as the chisel will glide through the stone cleanly and easily. Sharp chisels make the work a lot easier.

Link to video: *http://soapstone1.stephencnorton.com/home/sharpen*

If you were using a hammer or mallet, and drove the chisel into a quartz inclusion, you may have put a chip into the chisel blade. (This is another reason why I don't use hammers.) If this occurs, you may need to resort to using a file, or possibly even a grinding wheel, to remove the chip from the chisel blade. The process is the same as described above, you're just removing more steel from the edge of the blade. Chiseling with a chipped blade will leave uneven marks across the stone, so it's best to keep the chisel blade edge smooth.

Chapter 8 - Really Getting Started

OK, you've picked out the perfect stone, but you have no idea what you want to do with it, other than create a magnificent carving. Start by looking at the stone from all angles, including upside down and backwards. Sometimes simply inverting the stone will bring an image to mind, giving you a starting point. Let's look at this stone.

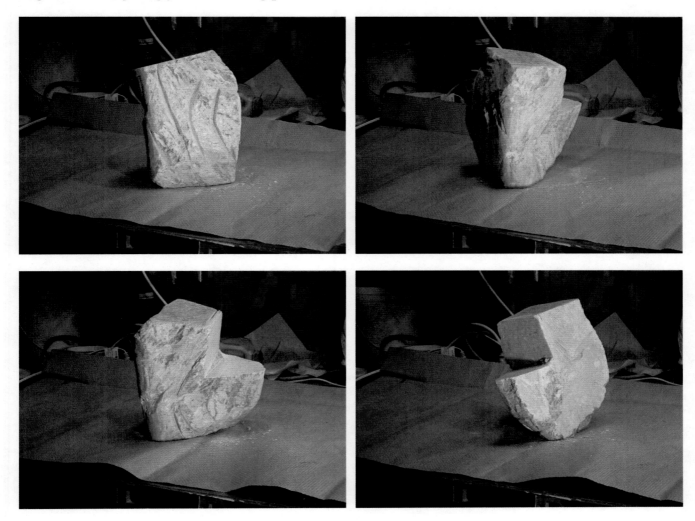

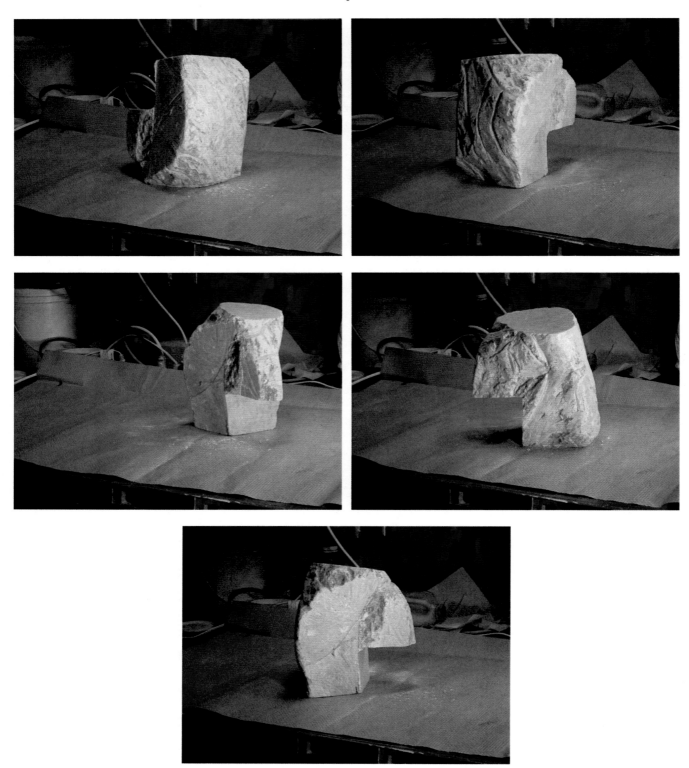

If something pops into your mind, sketch it out while you think of it, either on paper or on the stone, then start work. Sketching on paper is usually best, as you still have the original image to reference, even after you've shaved the initial image off the stone face. In the case of this stone, nothing came to mind for me. I'm still working with a blank slate, and as I've had this piece for a while, and nothing has come to mind so far, we're going to use the Chaos Method. You'll notice that a chunk of the stone has already been cut out. I thought I'd try a

smaller piece, but as I warned earlier, a stone silent piece tends to stay silent, even in smaller pieces.

As we have no image to work towards, let's simply start working on the stone. Saw off some of the sharp corners. Get the big rasp out and round out the edges. If there's a curve going into the stone round that out, maybe accent it, make it deeper, wider. Remember there is no wrong move at this point. You have no image to work towards, so you can't make a misstep.

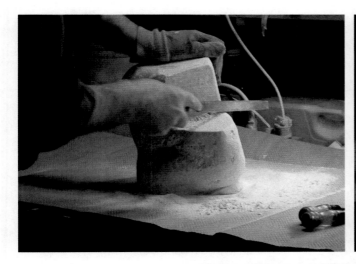
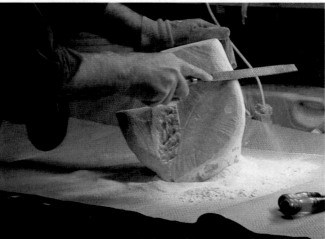

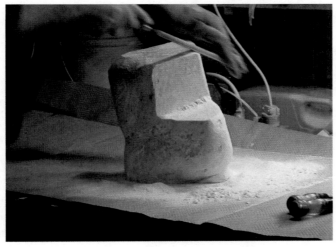

For inside edges, turn the rasp so the half-round face is against the stone. This will change the sharp 90 degree angle in the stone into a more rounded curve. Continue rounding until the entire stone has been rasped and smoothed. Sharp edges should be round, rough surfaces should be smoothed, corners should be soft, more of a shoulder than sharp corner.

Now step back and take another look at the stone. Looks a little better, but still no great inspiration. Carry on.

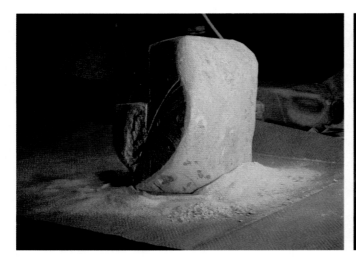 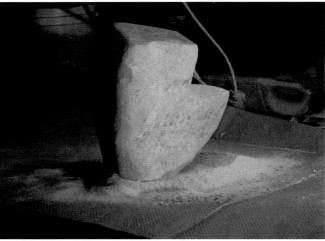

Drill some holes. That always makes a big change to the look of the piece. Remember to watch where the drill is pointing and where your hand is supporting the stone. DO NOT drill into your hand!

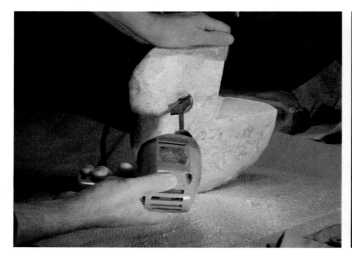 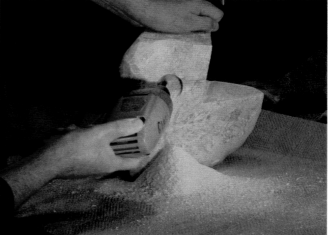

In this case, I decided I wanted big holes, so I'm using a hole auger, a slim drill bit with a wide cutting blade at the end (1 1/2" in this case). Augers allow you to make big holes very quickly, but remember to keep the drill speed slow in order to minimize the amount of dust kicked up. Look around the base of the stone in the photos and you can see the amount of waste dust and debris produced by drilling one hole. If I'd used a higher speed on the drill, much of that dust would have sprayed across me and the floor around me. Slower speeds allow the dust to fall onto the work table. Once the drill bit is entirely inside the hole you can allow the drill speed to go faster.

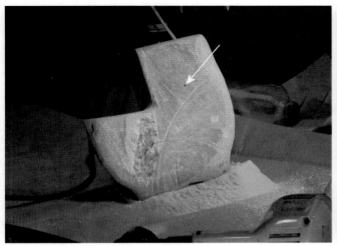
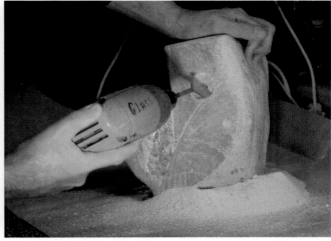

When using an auger, ease back on the drill as you approach the back of the stone. The auger has a leading point which will reach open air a little before the auger cutting blade does. The picture above on the left shows the hole from the back side of the stone, just before the blade penetrates all the way through the stone. Now drill into the stone from the back side, using the auger break-through hole as your guide. This allows you to cut a hole all the way through, without producing a rough or crumbled break-out edge on the far side. This can be important with soft stone, as a hole drilled all the way through from one side can produce a very jagged, broken exit hole, and potentially damage the stone in a way which would change the image you had in mind.

Link to video: *http://soapstone1.stephencnorton.com/home/drill*

Once the first hole is done, take another look at the piece. Still nothing? Well, put in a couple more holes. Once you've added a few holes, get the rasp or Sureform out again, round out the hole openings and edges and see what you have.

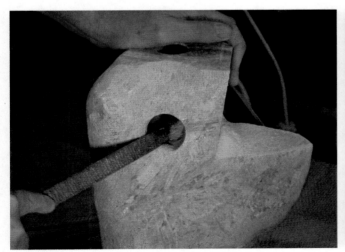
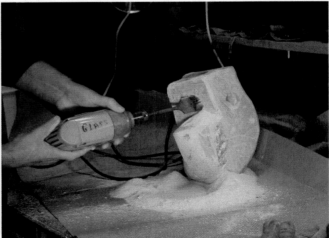

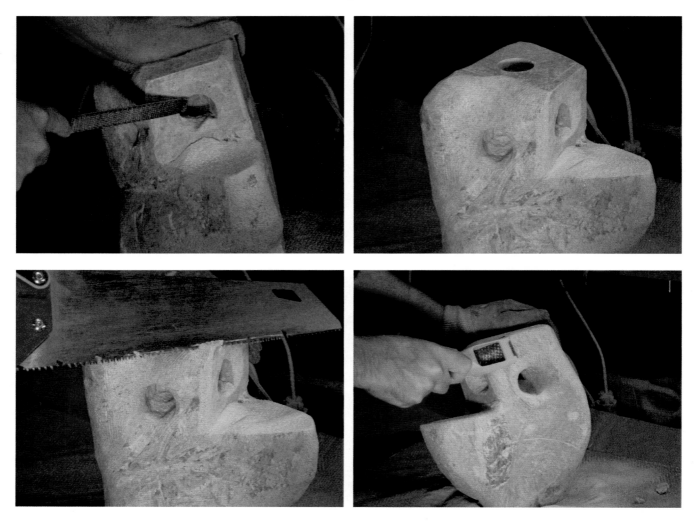

OK. Rounding is done, some holes drilled, corners snipped off. Let's see what we've got.

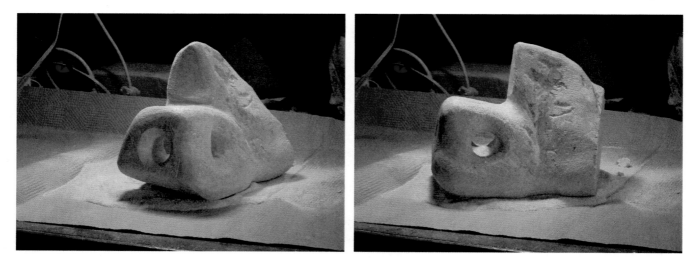

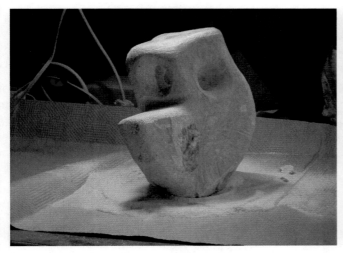 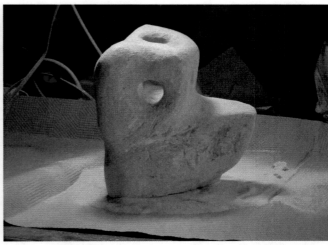

Remember to look at it from all angles. See anything yet? That last image looks kind of interesting - some sort of eagle head maybe? If it looks interesting see what else you would need to do to bring out that image. If it doesn't really look all that interesting, maybe drill some more holes, or cut a few incisions into the rock. Even if nothing ever presents itself, you will still end up with a nice sculpture, it will simply be a free-form or impressionistic piece. Don't worry. I've done a few pieces which looked like something to me - a sail boat under full sail, which no-one else can see. But they see something else. It's quite common to have someone say, 'Hey, that's really neat. I really like that piece, what is it?' then when I tell them, their response is ... "Really? No, I don't see that. What I see is'. I've found it's better not to say what I see, just encourage them to see their own image. So, fear not, the work is not in vain. You will continue, you will triumph, and you will produce a beautiful finished piece. You just don't know what it's going to be at this point.

Let's carry on and do some more things to this piece and see where we go.

Chapter 9 - Doing More to the Stone

As we're still not sure what we're going to end up with, but we do know that we're not happy with the shape as it is, let's carry on changing the look. The 'nose' looks a little too much like a cartoon character, so let's cut it off. This means going back to the hand saw to make quick changes. Just be sure you're taking off what you want.

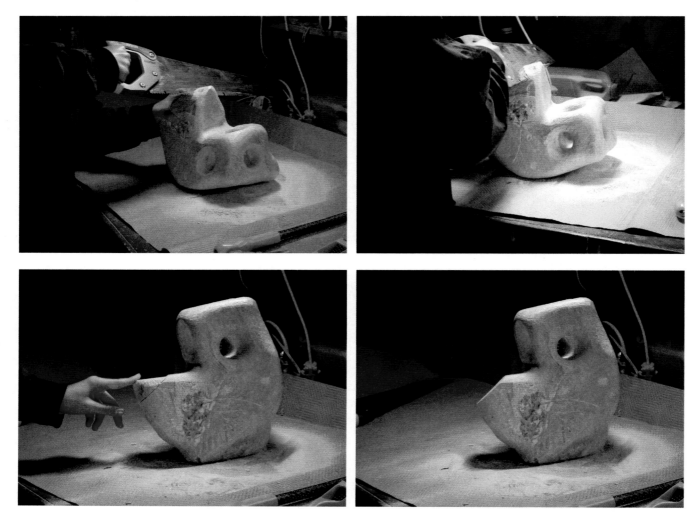

Still looks a bit cartoonish, but round it out and that may fix the problem. Drop in a few more holes in strategic places, round out the results and carry on.

Joining or linking holes usually adds to the look of the piece. Drill one hole all the way through the stone, as we have below, from side to side. Drill a second hole through the stone at an angle, until it intersects the first hole, then stop, as we have below, from the front. This allows light to enter the holes from different directions, which helps catch the eye and provides interest to the piece. Strangely, drilling two intersecting holes completely through the stone doesn't add as much interest. The asymmetric look often seems to appeal to the eye more than full symmetry does.

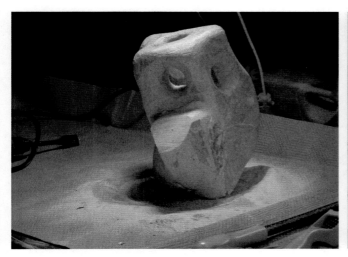
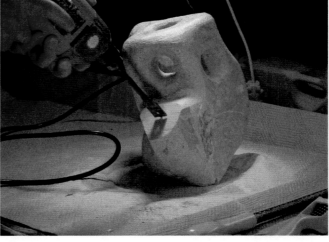

Link to video: _http://soapstone1.stephencnorton.com/home/drill_

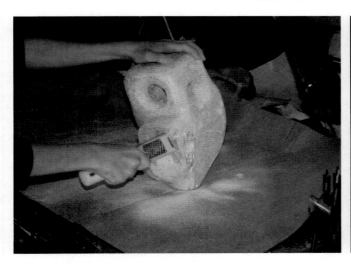
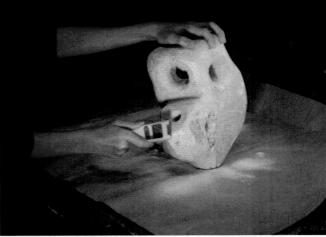

The sides look kind of plain, so does the back, so lets give them some character. Cut in a shoulder, or cheek, depending on where you put it and what you think it might be. Rounded curves <u>always</u> look good on stone, so don't be afraid to add some in.

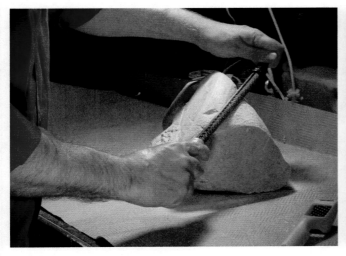
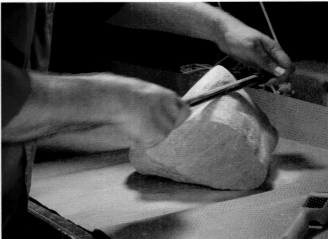

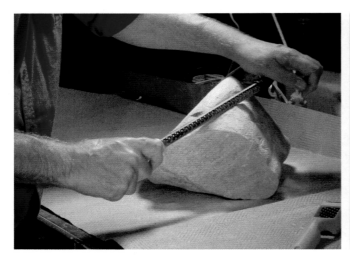
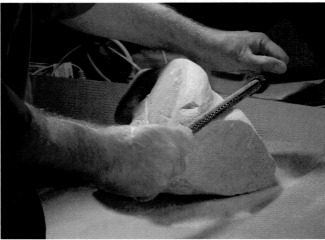

Sometimes it helps to give yourself a guide while cutting into the stone. Below, I've drawn in a couple of guide lines, using my soft lead pencil. This allows me to see the change I'm planning on making, and to get a rough idea of how it will look after the cut. This also allows me to adjust things before the cut, which is easy, rather than trying to fix things afterwards, which is next to impossible. And yes, we're now combining the Chaos Method with the Rational Path, but that's OK.

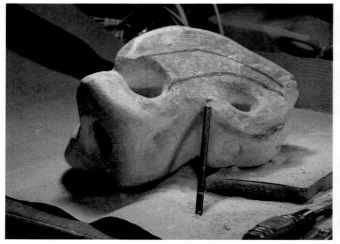
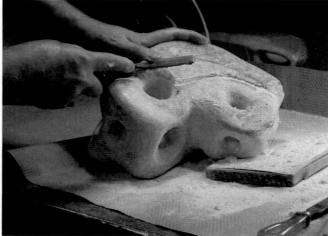

Once the pencil lines are where you want them, start be making shallow grooves, using one edge of the chisel. The flat edge of the chisel should follow the pencil mark, while the angled edge should face the 'waste' area of the cut ... the stuff you're going to cut away. Don't press too hard or dig too deep. At this point you just want a light pressure, barely scoring the stone. Make a shallow cut all along the pencil lines. This groove should angle in towards the stone which will be removed. This acts as a guide, both visually and for the tool, as it tends to push the cutting edge into the waste stone area, rather than pushing out into the image area. Having the cut push out can cause it to cross the pencil guideline, and thus change the shape and location of the cut.

Check the shallow grooves, make sure they are where you want the cut to be, the curve is correct, and the resulting cut looks to be what you want. If it's not, you still have the option to erase the shallow groove and change your mind. If it's still what you want, go ahead and deepen the grooves. Once the grooves are reasonably deep, remove the stone between the

grooves. If you want the indent to be deeper, repeat the process. Cut in the side grooves to guide the cutting area, then remove the stone between the grooves. It's always better to do this in several small stages rather than all at once, as this gives you some lee-way. You can stop before you had originally intended if the actual cut looks deeper than you had imagined. If you make the grooves very deep in the first step, you're committed to make the entire cut that deep, which may not be what you really wanted. In carpentry they have a saying: 'measure twice, cut once'. In soapstone it becomes 'cut twice, or cut three times, never cut once'.

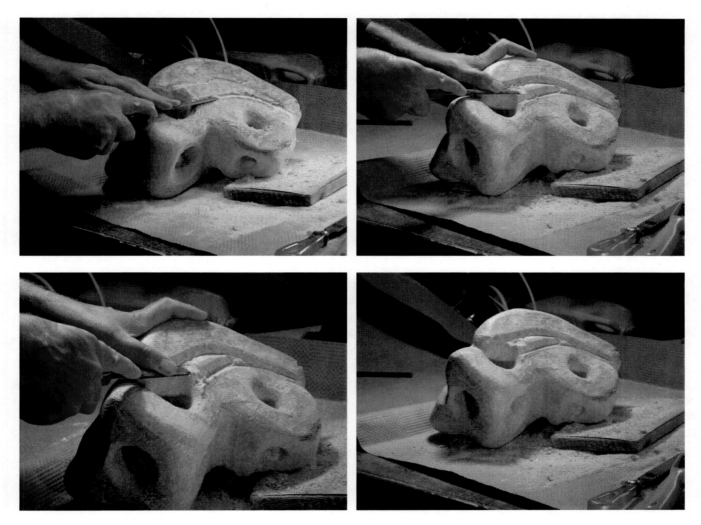

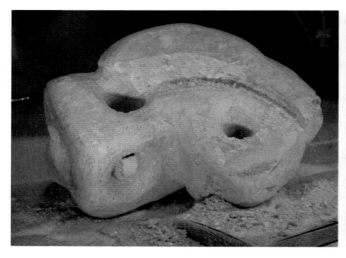 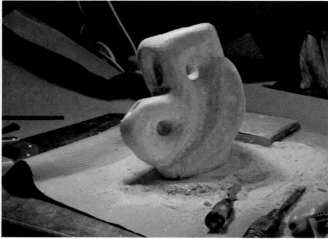

Link to video: *http://soapstone1.stephencnorton.com/home/grooves*

The groove looks good. As you can see, the groove creates curves, shadows and layers in the stones surface, all of which add eye catching areas to the piece. Look around the piece and decide what else we can do to enhance the look. We could put another groove in, possibly a matching one on the other side of the stone. I'll think about that for a moment. I don't think we need any more holes as we already have a fair number of them. We don't want too many holes or they'll detract from the overall look.

Earlier we put in a shoulder on one side of the piece with the rasp. That looked good, but the other side, what I'm calling the back of the piece, still looks very plain, so lets cut a shoulder into that as well. Trouble is, there's no flat side now to lay the rock on so we can cut in the grooves for the shoulder. No problem. All we need is something to hold the stone at a nice angle for us to work on.

I could make a wooden jig for this, but with the size of the stone we're working on that would make a pretty big jig. Instead, I like to use an ice cream bucket, as the stone's weight will hold it down, and the plastic bucket will fold itself slightly around the stone and hold it firmly without damaging it. At this point, the minor scratches the bucket will inflict is not a problem, because they'll be removed during sanding. Now we can work on the back without having the stone wobble with each cut. A stone which wobbles around while you're trying to cut it will likely lead to you spilling some blood on the piece, and probably getting another First Aid badge.

Use the same technique as we used for the first groove. Pencil in the guidelines, cut leading grooves, remove the waste stone between grooves, repeat as many times as you want.

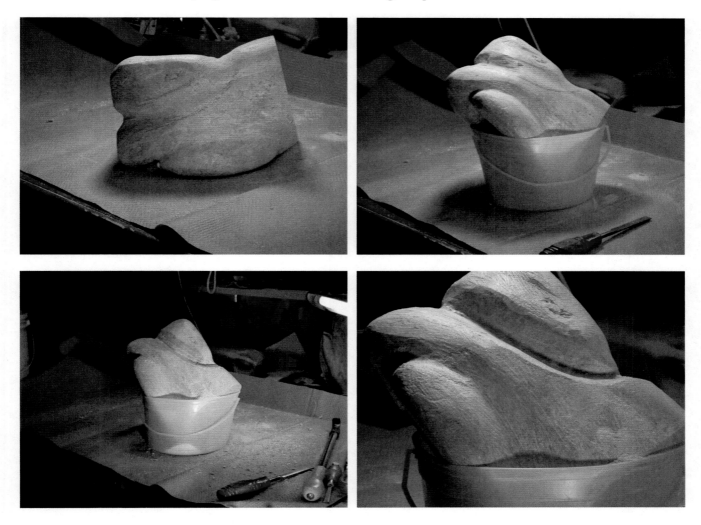

Once the cut is completed, stand the piece up the way it would be when finished and check the look. If it doesn't look quite like you want, go ahead and continue removing stone until you're happy. Once it looks good, clean the cut surface up by smoothing the cut areas, either with a rasp, file or chisel, then move on to another area.

We're getting close to our final shape, so now it's time to start fining up both the shapes and the surfaces. Because we have a lot of curves, that will be done most easily with the specialty rasps. They have curves that allow us to work on both the inside and outside curve surfaces.

Notice that I'm not wearing a glove for this. I should have! Usually, the specialty rasps require a glove to protect your palm. I got away without a glove this time because I'm only doing surface cleanup with the rasps, not actual shaping. This means I'm using a lot less pressure, and I'm very unlikely to hit an inclusion and have the rasp jam itself into my palm. However, you should make it second nature to use protection whenever it might be needed. If I had hit an inclusion I could have put a nasty gouge in my palm.

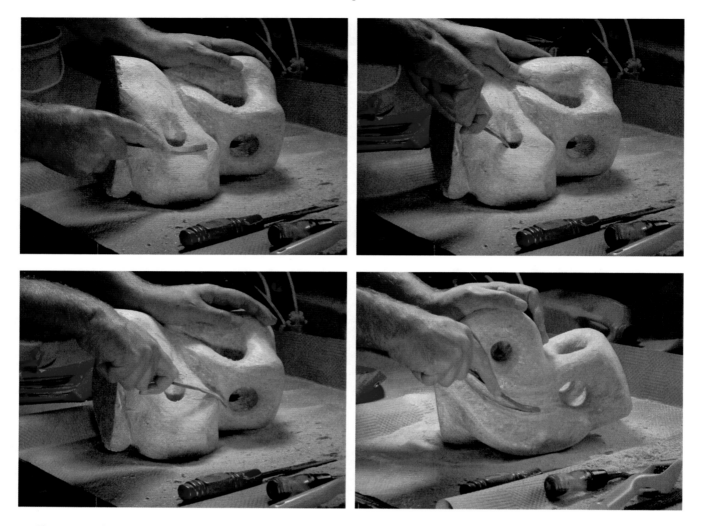

I've mentioned a couple of times that you should smooth the stone once you're happy with the cut. Chisels, when used for deep cuts, leave blade marks on the rock. Rasps leave fairly deep grooves. Even the specialty rasps will leave some surface gouges. These can be removed later, at the sanding stage, but that increases the amount of sanding required with coarse paper. As we'll see later, very coarse paper tends to break down fairly quickly and that can be a bit of an annoyance. Instead, I prefer to use a chisel to remove the deeper marks on the stone.

Hold the chisel almost flat to the stone surface, with the angle on the blade facing upwards. Run the chisel lightly across the stone, keeping the blade angled just enough to take off a bit of stone, but not so steep that it's actually digging into the stone. Think of it as if you were shaving with a straight razor. You just want to remove the stubble, not cut the skin. You can use this technique almost anywhere on the stone where your tools have left grooves or gouges. It definitely removes the gouges faster than using sandpaper.

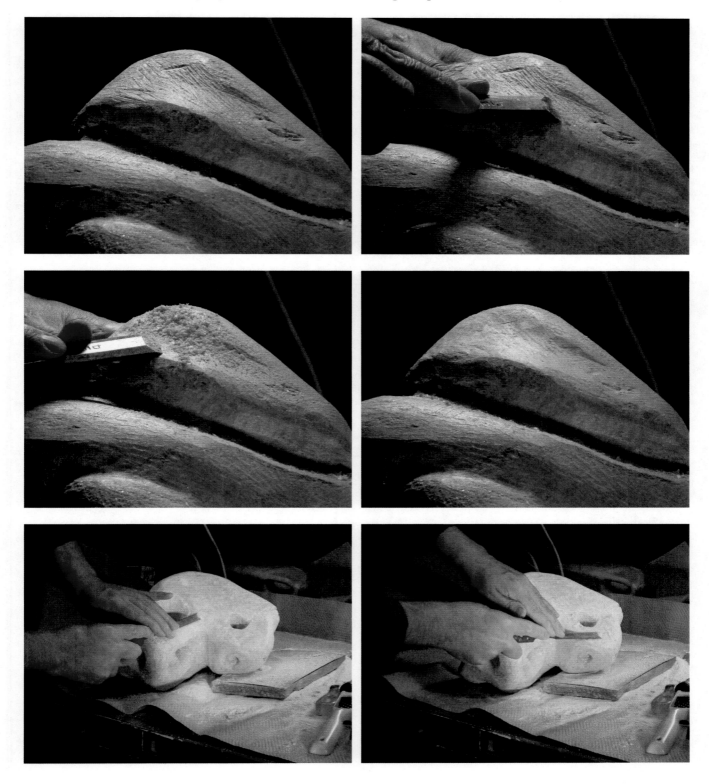

Link to video: *http://soapstone1.stephencnorton.com/home/smoothing*

Removing Blemishes

You're using raw stone, so sometimes there will be a blemish on the stone where you want a smooth, flat, surface. Rather than removing a lot of stone to bring the entire surface down so it's completely flat, simple scoop out the blemish and blend the 'scoop' into the flat area. It won't be entirely flat, but will add some texture to the area without drawing the eye to a blemish. Trim away the stone around the blemish so that the edges blend into the lower area where the blemish has been smoothed. It doesn't need to be perfect at this point, as sanding will take off more stone and cause the blemish / divot area to blend in even more. If after sanding it still doesn't blend enough, you can always bring out the chisel again and remove more stone later. For this task I find that the smaller, palm-grip chisels work best.

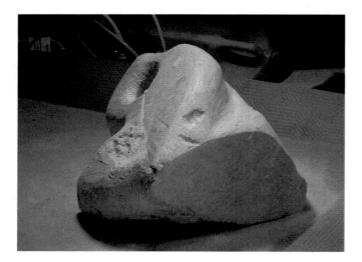

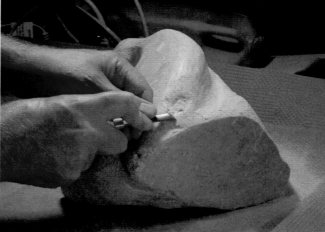

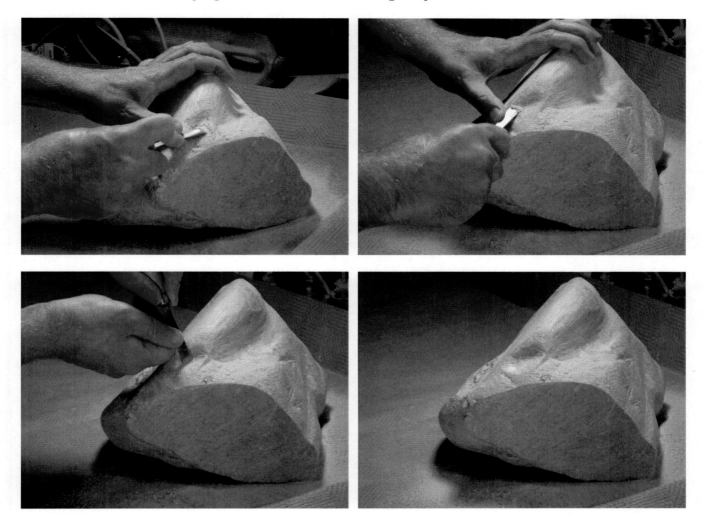

Link to video: *http://soapstone1.stephencnorton.com/home/smoothing*

Finishing the Base

At this point I think we have the overall shape pretty well mapped out, and thus we know if the base is where we want it, and if it is at the correct angle. If it's not, then it's time to get out the big saw again and cut a new base. In this case, I'm happy with the base where it is. It's already fairly smooth, so I just need to ensure it's flat all over. I do that with my sanding board.

First, sit the stone on a couple of wooden supports, so the entire base is exposed and clear of the table surface. (This is exactly the same as you do when you are cutting the base.) Then use the sanding board to work on the base area. Hold the board as flat as you can, keeping the entire base surface in contact, so the sanding will occur across the whole area and stay flat. Then sand using a circular motion. If you sand in a to-and-fro motion you run the risk of sanding in new surfaces, as your hand tends to put more pressure on the back of the sanding board when you push forward, and on the front when you pull on the backwards stroke. A circular motion helps to keep the sanding board flat, thus ensuring the base is sanded flat. Remember, you want the piece to sit firmly and squarely on the base, with no wobbles. That means the base must have a single, flat surface.

On small pieces, getting a completely flat base surface is reasonably easy, but on larger pieces it does take a bit of work. For that reason, I'd recommend you practice a few times on scrap stone before tackling the base of your masterpiece.

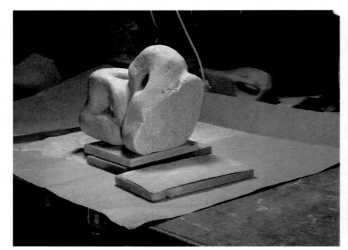
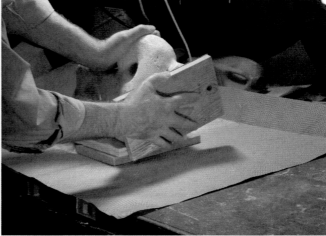

Once the base is done, you're ready for the next steps - sanding and finishing.

Chapter 10 - Sanding and Finishing

I think we've reached a point now where we've done enough. We have an interesting shape, some nice curves, holes, and details. The piece has it's own character and will generate a reasonable amount of discussion about what it is, what it depicts, and what it really looks like. The heavy cutting and carving is done. Just to be sure, set it on it's base and take a good look at it from all sides. Are you happy with it?

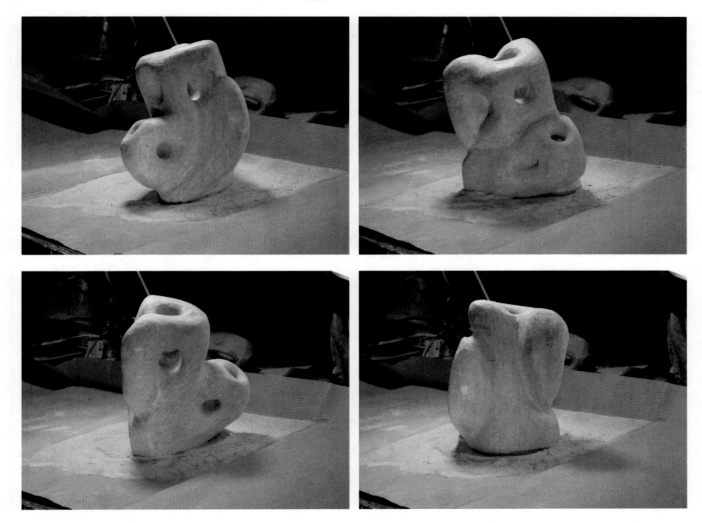

OK. If you're happy with it, then we go on to the next step - sanding. At this point, as far as work and labor are concerned, we're about half-way there. Sanding will take up as much or even more time than the carving did, but it's at least as important. A great shape that's been poorly sanded will ruin the finished piece.

Sanding is done in several stages. You start with a coarse grade of sandpaper, usually 80 grit or 120 grit. The shape of this piece is still fairly rough and because we didn't do much surface clean-up it still has a fairly rough surface texture, so we'll start with 80 grit. If the stone was of a finer texture, or we'd spent more time smoothing the surface with a chisel or fine file we'd start with 120 grit.

I've already mentioned dust, but I'll mention it again. Dust is bad! If we do the sanding dry, we'll kick up huge clouds of dust and spend all our time wearing a dust mask, coughing, and cleaning up. I do ALL my sanding wet, using wet/dry sandpaper and lots of water. Below is my sanding set-up. A large flat catch plate with raised sides for catching the water and debris. An ice cream tub half-full of water, a sponge for applying the water, and the sandpaper. Sandpaper comes in 8x10 inch sheets. I always cut the sheet down, so I'm working with a piece of paper about the size of my hand. The coarser the paper, the faster it breaks down, especially if you're sanding tight curves and inside holes, as the coarser paper is quite brittle and tends to crack. However, sandpaper is also cheap so don't worry about it. You'll probably only use a couple of sheets of 80 and 120 grit. After that, the paper tends to last longer, though the more you use a sheet, the finer the grit gets. That's right, if you start with 120 grit and use it for 30 minutes, by the end it will be acting like 180 grit or finer. This is because the grit wears down while it's wearing down the stone. This means that if you've done a stone with a single piece of paper and are thinking about starting a new piece of sandpaper just to finish up, don't use a piece of the same grit. Move up one level of grit, or you'll be re-introducing roughness back into the stone.

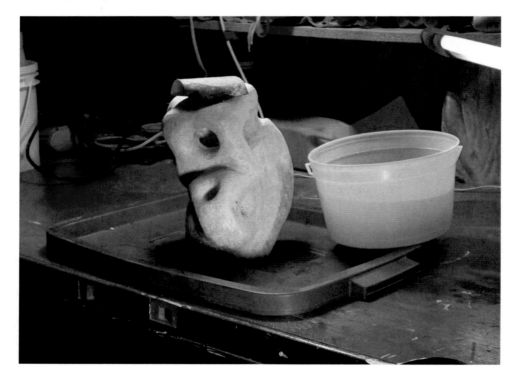

To start, wet down the entire stone, wash any dust and debris off on the stones surface.

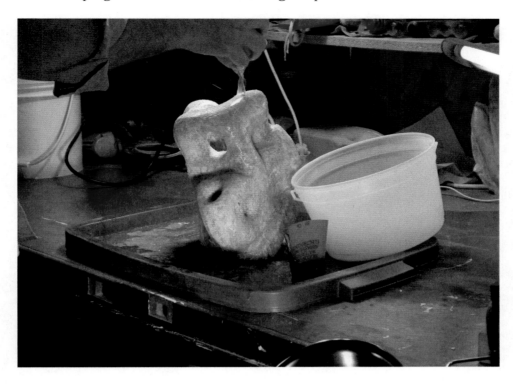

Then start sanding. Press gently. If you press too hard the sandpaper will score the stone surface. A brisk circular motion is best, but obviously that doesn't work on all areas of the stone. For sanding inside the holes, wrap your finger with the sandpaper, making a tube with the grit out, then sand inside the hole with your finger. If the hole is too small, wrap the paper around a pencil or round piece of wood, like doweling, so you can get inside the hole.

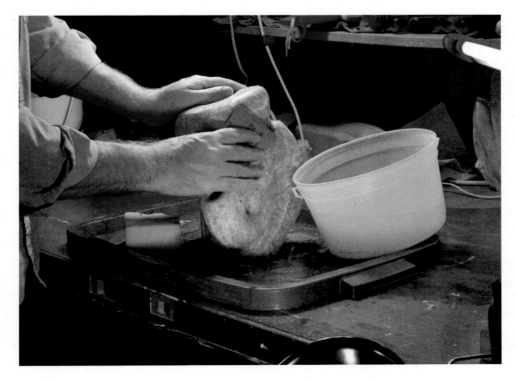

Sand the entire piece with 80 grit paper. Once you're happy with the result, move up to 120 grit and sand it all over again. Often the sanding will expose deeper grooves and score marks. You can either sand these down with the paper, or go back to a chisel and gentle

smooth out the groove, using the same technique as you would for removing a blemish. Then go back to using the sandpaper. You're sanding to remove all score marks, however, 80 grit is pretty coarse so there will still be small scores on the stone when you're done. Don't worry. Move on to the 120 or 180 grit paper. As the grit becomes finer, the score marks left behind will also become finer, until they're so fine you can't see them any more.

Remember to keep both the stone and the paper wet. As you apply the water, you'll notice the stone changes color. As you sand, the color change will become more and more apparent. It's most noticeable when you first start. The change between raw stone and stone sanded to 120 grit is astounding. However, as you progress, the stone will continue to show more color and pattern.

The picture on the left below is the dry stone, before sanding starts. The second photo, on the right, is the same stone, before sanding, simply wetted out with water.

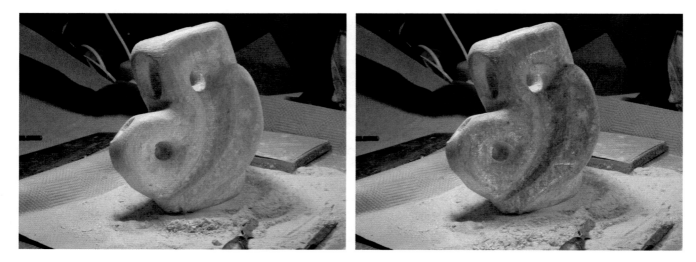

The photo below shows the dramatic change that sanding provides. The whitish side on the left is un-sanded, the greenish side on the right is sanded with 80 grit paper only.

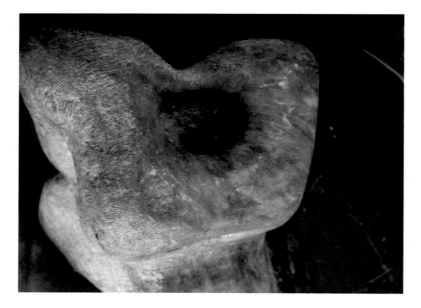

The next two pictures are of the same stone after 80 grit sanding is completed.

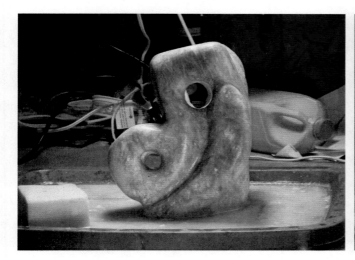 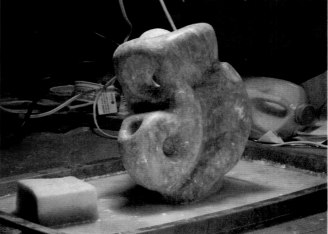

You can now see the true color of the stone as it changes from a dusty grey to a beautiful mottled green with brown flecks. As the sanding progresses up to 800 grit, or 1200 and 1500 if you choose to go that far, the color will deepen and become clearer.

Don't stop at 200 grit and think you're done. Look at the photo below. Same stone, same Tung oil finish. The only difference is that the thinner end on the left is sanded to 180 grit, and the other end to 800 grit. The moral.... don't skimp on the sanding!

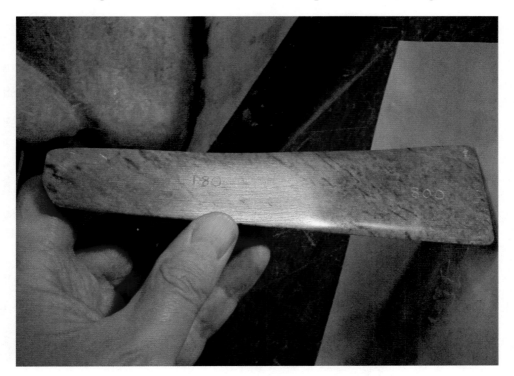

I'd like to focus on sanding in a bit more detail, as it is what makes or breaks the finished piece, so let's repeat just a little. A full sheet of sandpaper is 8" by 10", which is much too big to work with easily, so I cut the sheets down to something about the size of my hand. This makes the paper easier to handle, especially with the coarser grits like 80 and 120, which are fairly brittle.

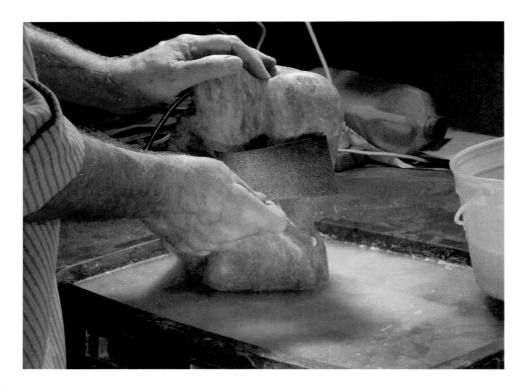

Sanding is done in whichever direction makes sense for the area you're working on. Circular is usually best as it leaves the cleanest surface, but in many places circular simply isn't possible. I use a clockwise motion, but counter-clockwise works just as well. Whichever you're most comfortable with.

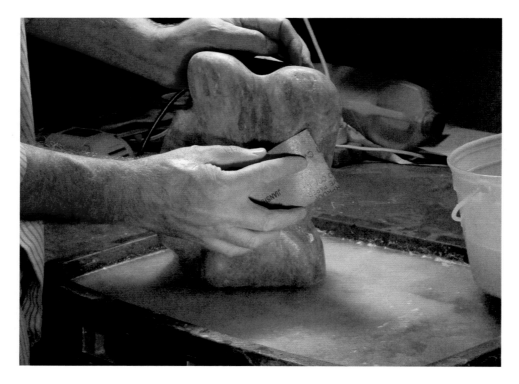

You can tell when the paper is finished, as it looks like the piece below. Throw this piece out and start with a new piece. On a large piece of stone, you may go through several full sheets of 80 grit paper, and probably at least a sheet, possibly two, of 120 grit.

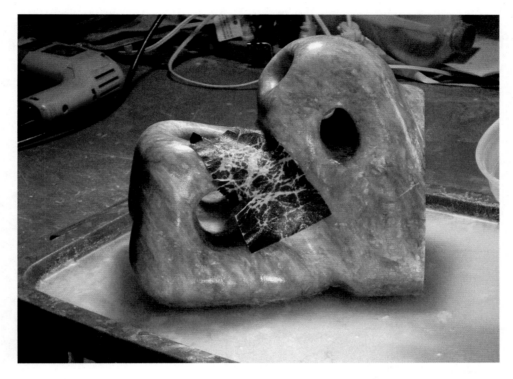

Make sure you keep the sanding area well wetted out. This acts to keep the work surface clear, so you can see what you're doing, and provides a bit of lubricant, making the sanding a bit easier. It also clears the surface of the paper, which will get caked with wet dust (mud) as you sand. If pouring water over the area doesn't clear the paper enough, simply dump the paper in the tub of water and wash it out a bit. Lots of water also keeps the dust in the water, forming a very loose mud. It might be a bit messy but it's much better than having the dust in the air. In the picture on the left below I'm sanding inside the hole, and the water is running across both the stone and the paper, keeping both clear of mud.

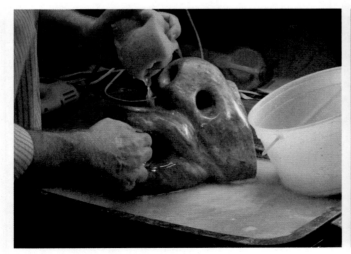 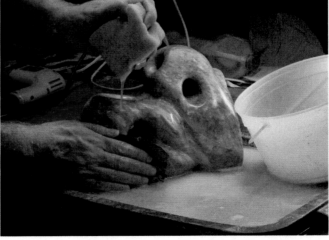

Link to video: *http://soapstone1.stephencnorton.com/home/wetting*

When you were cutting and rasping, I suggested empting the newspaper into a waste bucket every now and again, so your work space doesn't get drowned in dust. When sanding, you'll need to do the same thing, as the mud will build up and gradually fill your catch tray and water bucket. Empty the tray back into the bucket and wipe down the tray with the sponge to clear away all the mud. Take the bucket and dump it <u>outside</u> on the garden.

DO NOT DUMP IT DOWN THE SINK OR DRAIN !!!!!!!

If you put it down the sink and house drains, it will turn from mud to concrete and you'll need a plumber to come and clear the pipes. Dust goes outside, ALWAYS!, regardless of whether it's dry dust or wet mud.

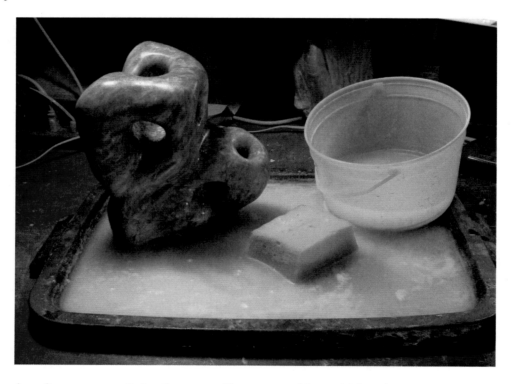

When changing from one grit to the next finer, say 80 to 120 grit, you should also clean up the mud, dump the water (OUTSIDE!!) and start the next grit with clean water, clean sponge and clean tray. Otherwise, as you're sanding with 120 grit paper, the water, mud and sponge, still contaminated with 80 grit, will be adding small bits of 80 grit randomly back onto the piece while you're working with 120 grit. This leads to nicely finished areas with occasional scratches in. Changing the water and washing down the piece between grits becomes especially important as you move into the finer grits, as the older, coarser grit will undo the sanding you've just done.

So, first sanding (80 grit) and second sanding (120 grit) are done. Review the piece wet, so you can see both the color and anywhere that you missed while sanding.

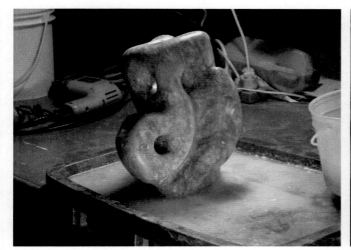 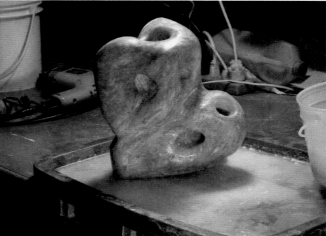

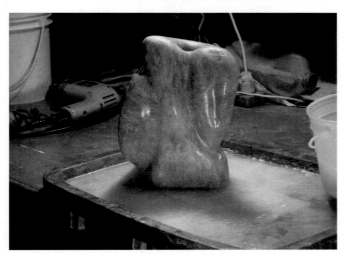

Now, review it again dry, so you can see any flaws or blemishes on the stone you missed when it was wet.

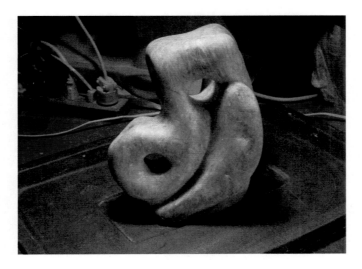

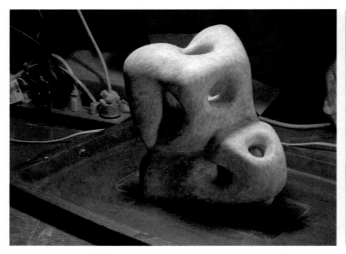 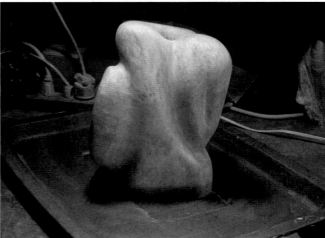

Notice that the sanding has changed the shape of your piece slightly. That deep shoulder isn't quite so deep any more. The holes are a little larger, the arches on the holes a little thinner. This is because the coarse sandpaper has removed another layer of stone. Keep that in mind as you're cutting down the stone to your desired shape. Leave a little extra stone so the sanding doesn't change the shape beyond what you're aiming for. On big pieces this is rarely a problem, but smaller, more delicate pieces can suffer if parts get too thin.

Now, look your piece over once more, and double-check that you're still happy with the shape / image that you've produced. Yes? No? Maybe?

Chapter 11 - Second Thoughts, Re-evaluation and Changes

Well, sanding to 120 grit is done, and I'm happy with the stone color and pattern. I can still see some spots that need a bit of attention, but I have to admit that I'm still not really happy with the overall shape that I have. It still looks blockish, maybe a bit cartoonish. I can't see a solution though, so let's get a second opinion. I asked my wife for her thoughts. She looked at it for a few minutes and - "Well, you've got a woman's profile and shoulder there, possibly in a lotus pose." Really? Where?

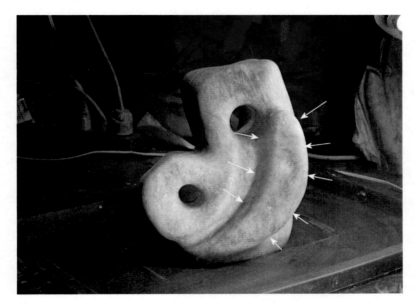

Hmm, yeah, I can see that now. That would look a lot more interesting than what I've got right now. Remember we're using the Chaos Method here, so let's make some more cuts.

The first side looks like a woman with her head up, shoulder and arm curved down. The other side looks more like a woman in lotus, bowing, possibly in a Namaste bow to her instructor. Get out the saw, and let's carefully cut a few pieces away. Now we have

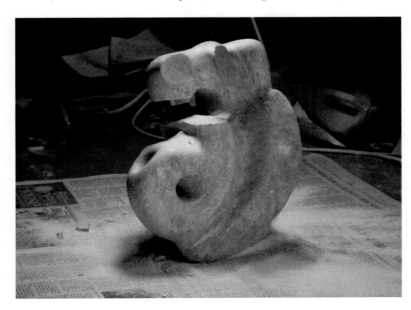

Looks nice. Round out the heads and faces. We're still doing impressionistic, so we don't need to worry too much about facial detail, just giving a general head-like look.

Link to video: *http://soapstone1.stephencnorton.com/home/second-thoughts*

Because of the location of the new cut faces, we're not going to be able to get the full-sized rasp or Sureform in there without scratching other areas of the piece. This means we move into using the smaller tools, including the small Sureform and the specialty rasps. The smaller size of the tools, and the curves on the specialty rasps, allow us to reach into the tight areas without scratching or damaging other, sanded parts of the stone.

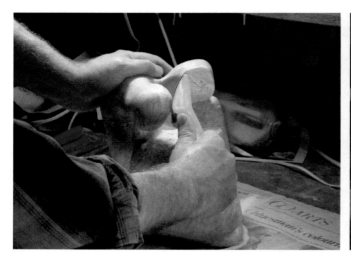 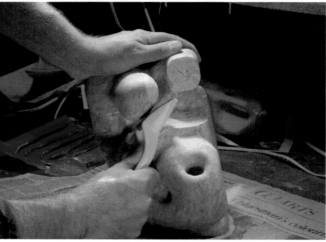

The heads look good, but we've really got two heads. From the back though, it looks like they're attached to the same body, so let's separate them. We don't need a full length separation, just enough to show that they're two separate figures. Maybe two women sitting shoulder to shoulder.

For this I used the little rasp saw, as this allows me to cut in any direction, so as I cut down I can control the direction of the cut, add a bit of a curve to the cut. I can also use the rasp saw blade to do a little smoothing and shaping as I go.

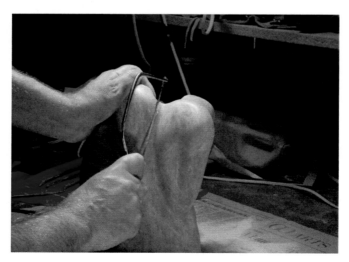

The large piece in front of the shoulder looks a little odd, so lets put in a second groove, as if the shoulder is holding a basket or something in front. The two curves, one in front of the other, add a nice sweep to the figure.

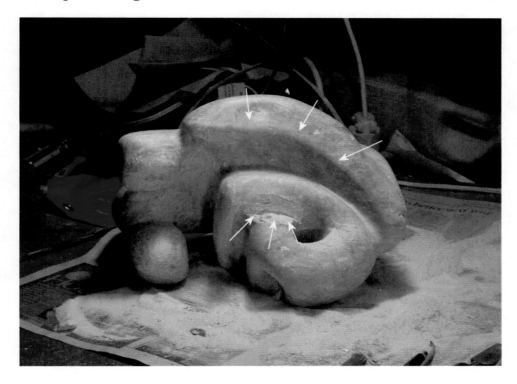

Now stand back and take a look at the piece again. It's definitely different to what we had a few moments before. The two sides have much more character and shape, plus some suggested motion and direction. The suggestion of a definitive action, even a simple sitting pose, gives the piece more life and makes it much more attractive. Static, fixed pieces with no suggestion of motion or stillness aren't as interesting for some reason, so we've definitely improved this piece.

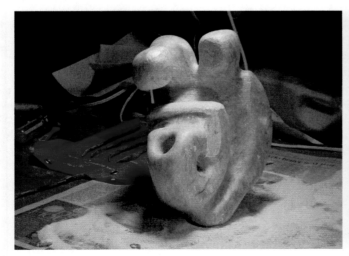
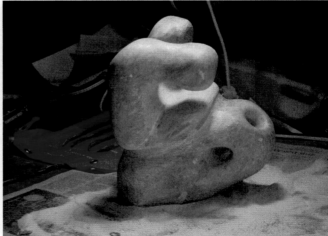

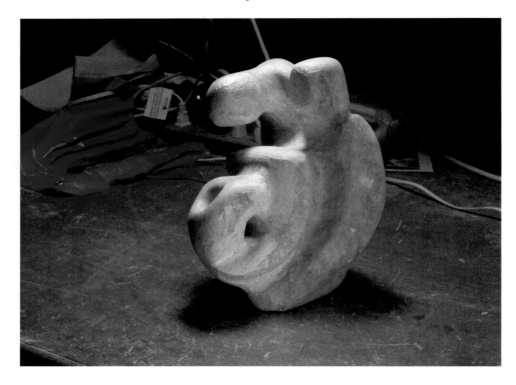

Much better. I like it! Only one problem.... Now we have to back up a step and go back to sanding.

Use 80 grit on those areas that have been newly carved or cut, then go over the entire piece again with 120 grit. Double check for any gouges or scratches introduced into the previously sanded areas by the sawing and rasping of the new areas. Those areas that were sanded to 120 grit, and haven't been changed, can still take a light sand, but pay close attention to the places where newly sanded meets already sanded. Make sure they flow together cleanly. Once you're finished, you shouldn't be able to tell where they meet.

So, as the Chaos Method suggests, the end shape isn't really attained until you apply the oil and polish the stone. You can always back up a bit and make some changes. If you're not completely happy with the image, always ask for someone else to review the stone. In fact, you should always get a second opinion at the 120 grit stage, just to double-check yourself. If it's a Chaos piece, they may see a completely different image than you, something you may like better. If it's a Rational piece they may see an odd-shaped fin that needs attention. Remember, you're looking at it so much that you may miss the minor issue because you can't see it for the stone - like not seeing the forest for all those trees in the way.

Chapter 12 - Fine Sanding and Smoothing

Once the 120 grit sanding is completed, give the piece a good wash in clean water, allow it to dry, then, as usual, step back and review the entire piece from all angles. As we've already found, it's really never too late to change our minds and go back to take some more stone off, but we have to draw a line in the sand somewhere and accept the shape as being final.

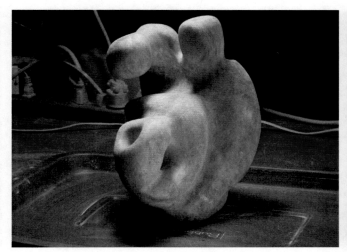 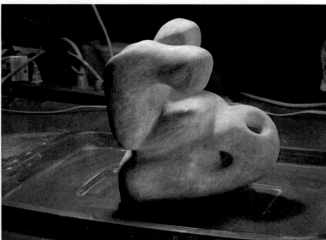

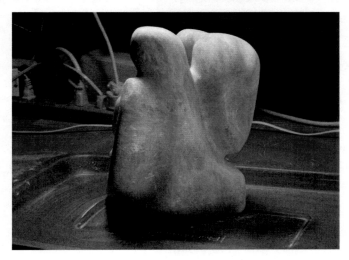

I'm quite happy with the shape as it is now, I can see two women, one in upright lotus and a second in bowing lotus, but it's still impressionistic enough that someone else could see something completely different. The base, with it's open holes and rounded surfaces lends itself to other interpretations. The shapes are nice. The curves are smooth and flow into each other. I think it's done.

However, if you look closely at the surface, you'll see that we've still got lots of work to do. The surface, after a 120 grit sanding, is still quite scratched. The scratches are small, but a finished soapstone piece should feel smooth and velvety to the touch. (This close-up is not in the actual stone color, it's simply to show up the scratches.)

So, back to the wet tray. Cut off a piece of 220 grit paper and get to work sanding. My usual sequence is 120, 220, 400, 600, 800. However, sometimes some grits are hard to find, so an alternative is 180, 320, 400, 600, 800. For small pieces, I like to get a much finer finish with the chisel blades or files before I start sanding. For large pieces though, that involves a lot of careful, small area work, so I find it easier and faster go from fairly coarse chisel work to 60 or 80 grit paper. The coarse paper replaces the fine chiseling. It's your choice, whichever way you prefer.

Sanding at 220 grit will change the color of the stone again, bringing out more depth in the color and more detail of any mottling in the color, as shown below. Left is 120, right is 220, both are wet stone. The change is quite amazing isn't it?

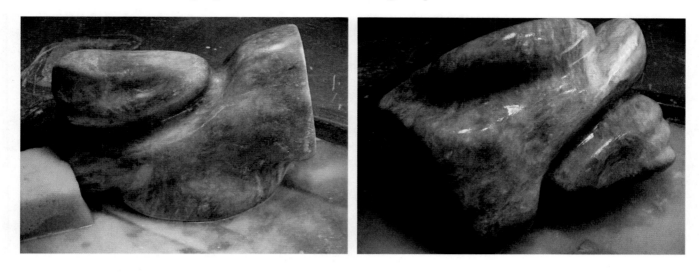

The third picture shows the same side of the stone, under the same light. The upper body on the right has been sanded with 120 grit, while the base on the left has been sanded with 220 grit. Both surfaces are wet, as this best represents what the final oiling will do to the stone.

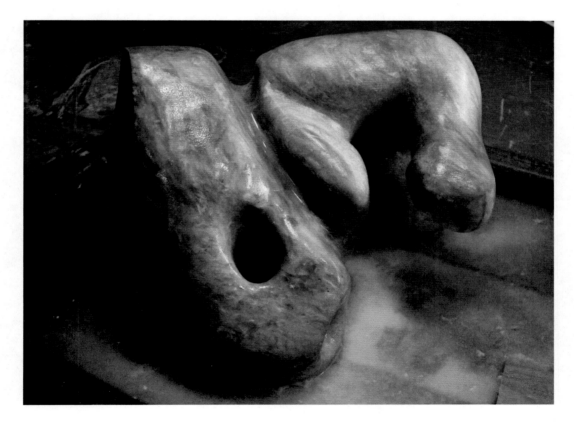

The other thing that the 220 grit will do is reveal any chisel marks or scratches that were missed. These can be removed by gently shaving the stone away around the chisel mark with a small, sharp chisel. I usually use my 1/4" palm grip chisel for this. Hold the blade flat to the stone surface and cut away the stone in razor thin flakes.

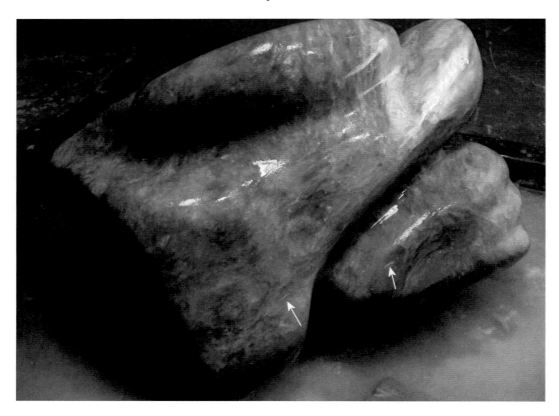

I know they look fairly minor, but they will be very easy to see when all the polishing is done. In fact, the flaws will actively attract the eye, and will definitely detract from the finished product. Take them out now, while you're still at the early sanding stage.

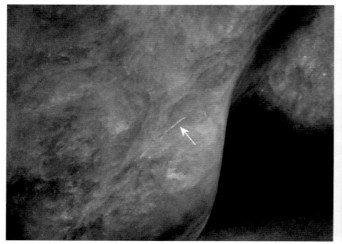

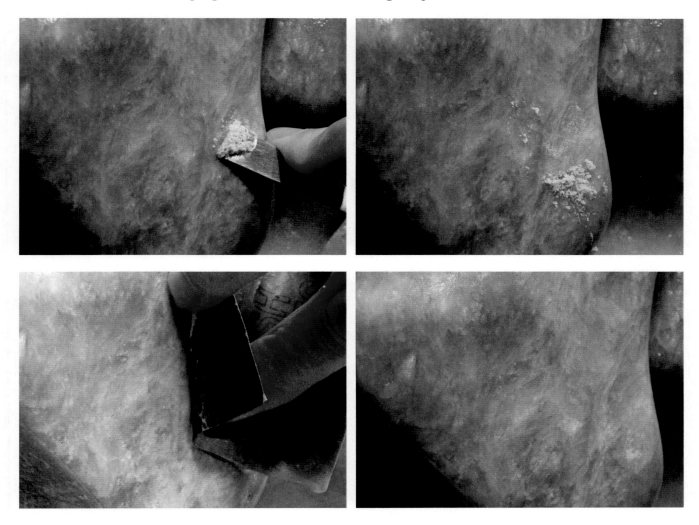

I use careful, fine chisel work, shaving the stone very lightly using the small, flat bladed palm handled chisel. Take off just enough stone to remove the mark, followed with 220 grit sanding to remove the mark entirely.

Deal with the second scratch-mark the same way.

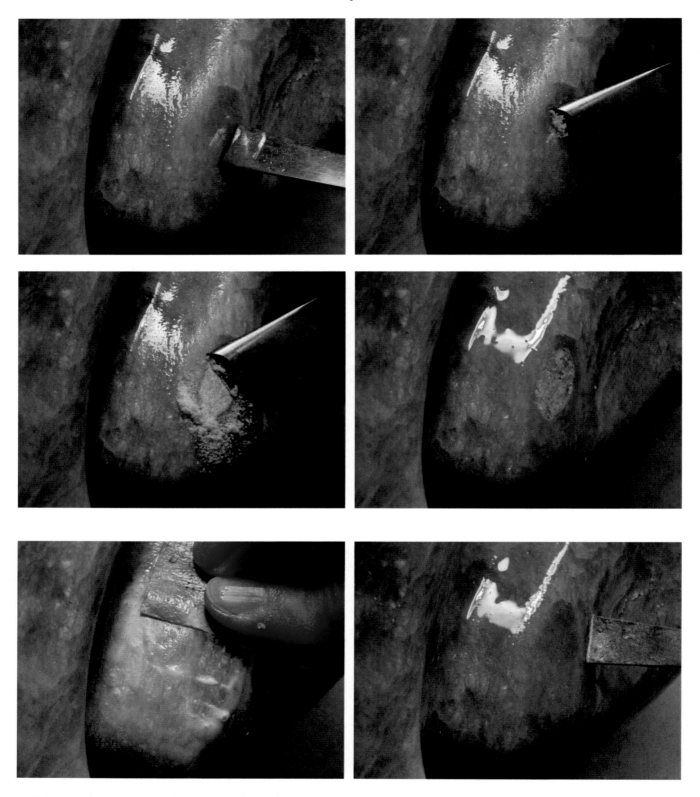

It's easiest to sand the entire piece to 220 grit first, then review the stone for marks. Remove the first mark, then move on to the next one. Continue on this way across the entire piece, identify a mark, remove the mark, sand to blend into the rest of the stone. Review the piece while it's still wet, looking for any missed marks or blemishes, then wash it clean and leave it to dry. Review it again once it's dry. Because the stone looks different dry and wet, some marks show up more clearly dry than they do wet, and vice versa.

Once you're happy with the 220 grit finish, and all the minor flaws have been found and removed, repeat the process with 400 grit paper. One suggestion for when you're sanding at finer grits: cut your fingernails as short as you can. There's nothing quite as annoying as finishing your 400/600/800 grit sanding and then accidentally scratching the stone with your fingernail. Pictured below is the piece sanded to 220 grit, followed by the piece sanded to 400 grit. Both are shown wet as that best indicates what the piece will look like oiled.

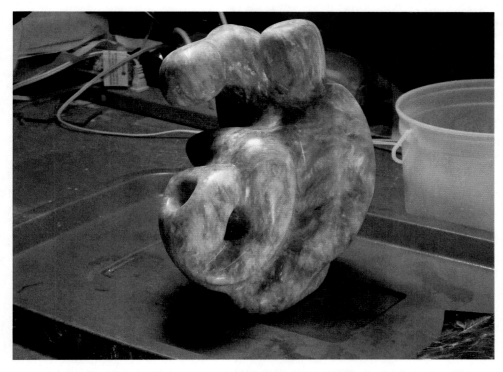

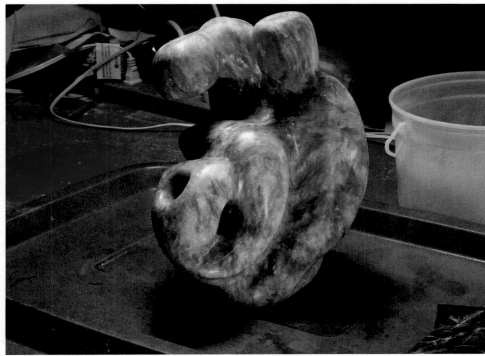

Review the piece again after the 400 grit is done and decide if you want to go to the next higher grit. Depending on the stone surface, and your own preference, you can stop at 400, or go up to 600, 800 or higher. Stopping before 400 grit is not advisable, as the rougher grits leave easily visible scratches behind. 400 is the first grit that doesn't leave clearly noticeable scratches on most stone. 600 grit is better still. This piece is a fairly soft stone, so higher grits will not have much more of an impact on the finish, so I think I'm going to stop at 600 grit. Because the stone has a mix of hard and soft areas, going to higher grits will actually accentuate the different areas, as the harder stone will take on a glossier finish. In this case it's best to stop at 600, so the soft and hard areas are still fairly evenly matched in finish.

Now, we've decided we like the piece and we're ready to apply the final oil finish. One last task to do first. Give the entire piece a good wash with clean water. For small pieces I do this in the laundry sink, under the tap, catching the waste water in a bucket. <u>DO NOT</u> let the dirty water go down the drain. When finished, dump the water bucket outside.

If the larger piece is too big to manage in the sink without risking bumps against the sides, take it outside and give it a good wash under the garden hose. Our intent is to remove all traces of dust, particles of stone and sandpaper from the piece. Once it's completely clean, set it aside to dry, which may take a couple of days, depending on the stone. Softer, more porous stone takes longer to dry completely than hard stone.

Take a breath! Take a break! You have to anyway, as the stone must be completely dry before you can go on to the next step. However, the bulk of the work is done. Only oiling and polishing are left, and that's fairly easy work.

While you're watching the stone dry, remember to double and triple check for any marks, scratches, chisel marks, dimples, blemishes etc. If there are any, back up and remove them. If the surface is smooth and completely clear of marks of any kind, review the entire piece as a whole. Are you happy with it? Does the piece speak to you? Do you like the stone color and pattern? Is it what you were hoping for? I hope the answer to all those questions is "yes!". Well done! Now put it all aside until tomorrow.

Chapter 13 - Oiling and Polishing

Oiling and polishing are very similar to sanding. However, where the sanding was done wet, the oiling and polishing can only be done with the stone completely dry. Once all the fine sanding is completed, to 600, 800, 1200 or 1500 grit, as you desire, wash the piece completely clean and leave it overnight or longer, so that it will be completely dry.

In this section I focus on oiling with Tung Oil, but there are other oiling / finishing methods you can use. Applying neutral colored shoe polish is one. You can simply rub it on with a cloth, let it soak in for a while, then polish it off, as you would if you were shining your shoes. Alternatively, you can put the soapstone in the oven and warm the piece to about 100 degrees Fahrenheit, then pull the piece out and apply the shoe polish. This warming method causes the shoe polish to liquefy when applied, thus doing a slightly better job of soaking into the small cracks and crevices of the stone. I have used shoe polish, but I find that over the course of two to three months, the shoe polish loses its shine and needs to be re-done. I have no desire to re-polish my pieces every few months, so I no longer use shoe polish.

Another alternative is to use a good quality, clear wood varnish. Applying liquid varnish has a number of problems associated with it. It requires that you apply it with a paintbrush. The paintbrush can drop bristles, and if those dry into the varnish it looks amateurish. The paintbrush can leave brush-strokes in the varnish. Again, if those dry into the varnish the finished piece looks amateurish. Varnish also has a tendency to form little drips and puddles on the surface of the stone, and great care and attention is required to make sure all the drips and puddles are brushed out before they dry.

Varnish does have some upsides though. Varnishes come in a variety of finishes, glossy, satin, or matte, allowing you a little more control over the final appearance. Varnish also provides a harder finish layer on the stone, which helps protect the surface from minor scratches. However, if a scratch does occur, the varnish makes the repair task much more difficult, as blending the repaired area back into the original varnish layer can be quite difficult. This can mean the repaired area stands out because the two varnish layers don't quite match up and a ripple or line is visible at the meeting of old and new varnish coats. To correct this you have to re-sand the entire piece to remove the old varnish, blend in the repaired blemish or scratch area on bare stone, then re-varnish the entire piece. I have used varnish, but did have to repair a piece which required a complete re-sand. It happened to be a large piece, and it took a lot of work to completely remove all traces of the varnish. Needless to say, I don't use varnish any more.

Tung Oil produces a finish similar to varnish, though it does not give quite as hard a surface coat. More importantly though, it allows easy blending of repaired areas back into the original oiled area with only minor sanding and re-oiling required. The only area sanded is the damaged area which is then feathered back into the original surface. I've never needed to re-sand the entire piece when using Tung Oil. The section on repair gives an example of this.

So, having covered some alternatives, let's get back to applying the Tung Oil to your finished piece.

While the stone is drying overnight, clean up the work bench. Remove all tools, dust, wet tray, etc. I wipe down the bench surface with a wet sponge, usually two or three times, to ensure I've removed all dust from the work area. If dust settles on the piece while the oil is

wet, it will dry into the oil and mar the finish. Spread clean newspaper on the clean bench and have all your clean lint free cloths and chamois' close at hand. Yes, clean is very important!

Using one lint free cloth, give the entire piece a light, dry polish to remove any dust from the stone. Put that piece of cloth aside so you don't use it during the oiling. It can be used again later, for polishing once the oil is dry. Pour a little of the Tung Oil into a bottle cap or jam jar lid.

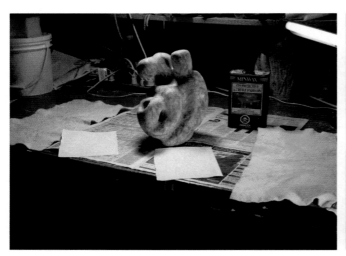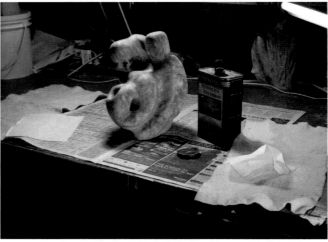

Now, using a clean lint free cloth, apply the oil to the piece a little at a time, rubbing it gently onto the stone. Rub the oil on with a circular motion to ensure the oil penetrates the grain of the stone from all angles. Don't swamp the stone with oil, but do apply enough to wet out the stone completely, then rub it in. Continue across the entire stone surface, occasionally wiping down areas that have already been covered, to ensure that there are no puddles or thick spots on the stone.

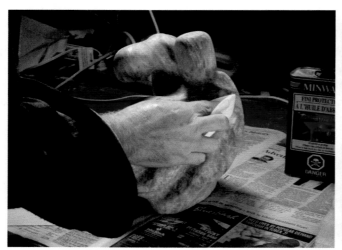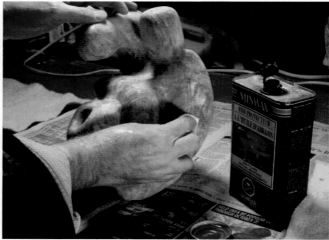

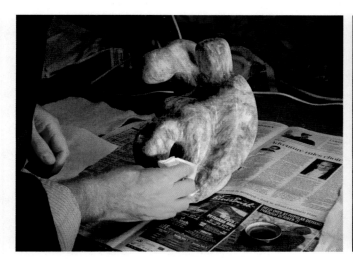
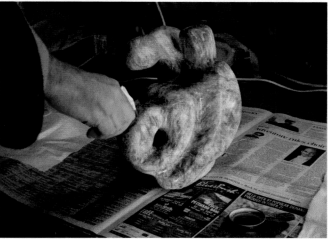

If your piece has holes, make sure you oil the entire inside surface of the holes. Some artists choose to leave un-oiled areas, but I think that makes the piece look unfinished. If you left some areas in a raw stone state, not chiseled, rasped or sanded, you should still oil those areas. The raw stone appearance does add character to some pieces, especially in bases, and it's a technique I do use, but all the surfaces should still be oiled to finish the piece.

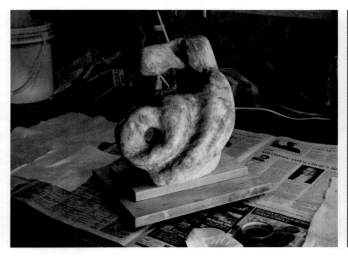
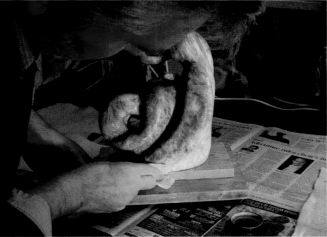

I use a 'Lazy Susan' table while oiling, to allow me to turn the piece with minimal touching of the stone. Regardless, make sure you oil the stone all the way down to the bottom of the base. I will also apply one light coat of oil to the underside of the base itself, just to seal the stone surface. Keep oiling until you've covered the entire stone. Continue to wipe the stone down with the cloth you used to apply the oil. As the oil dries, continue to gently wipe the stone with the oil-damp cloth. Make sure there are no areas where the oil is thick or tacky to the touch, then set the piece aside and let it dry overnight. The first coat of oil will be absorbed to some extent by the stone. The softer the stone, the more oil will be absorbed.

Once the first coat is completely dry, give the piece a good, overall polish with a clean, lint free cloth or chamois, then apply a second coat the same way. Dry polish first, apply oil, wipe down several times, set aside to dry. I normally apply three coats of oil, sometimes four or five if the stone absorbs a lot of oil. You have been polishing between each coat, but once the last coat is dry, give the entire piece a good hard polish with a soft chamois.

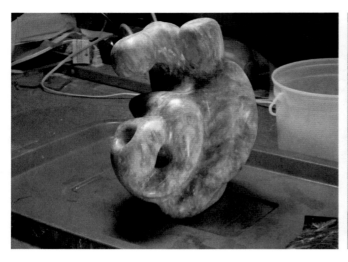 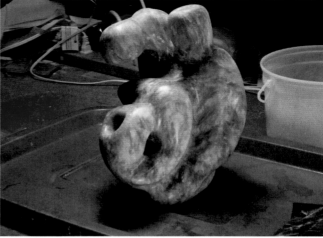

Finished piece before oiling. Finished piece after oiling.

Once the oiling is done, sign the piece using a Dremal tool or a sharp-pointed tool such as an awl. If you can't find anything else, a 3" or 4" nail works fairly well. I use a Dremal because I have one, and because it allows me to write almost as if I was using a pencil.

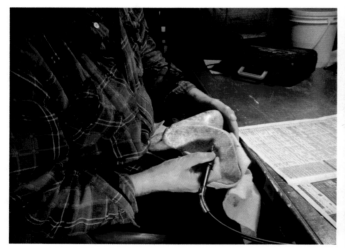 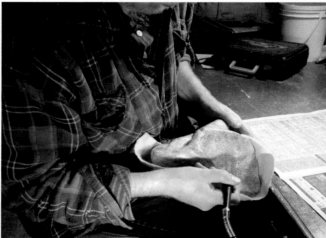

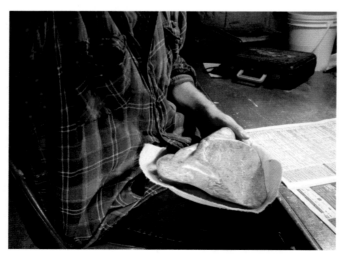

Notice that I'm holding the stone in chamois cloths to prevent scratches while I'm handling it. Also be careful of fingernails, as it's easy to scratch the surface. Yes, for this one step I am holding it on my lap, but I'm not waving any sharp implements around. The Scout Master would approve.

You can leave the stone to sit directly on its base, or you can add some felt or rubber pads to the base. Adding pads to the base will provide protection for both the piece and any wood furniture the piece is placed on, but could affect the balance of the piece. Make sure the piece still sits evenly and securely after the pads are applied. Three pads in a triangular pattern tend to make a more stable base than four pads in a square pattern. How many pads you apply depends on the size of the piece, it's general shape, and your own preferences.

Well, we seem to be finished. However, as always, step back and look at the piece from all sides, just one more time.

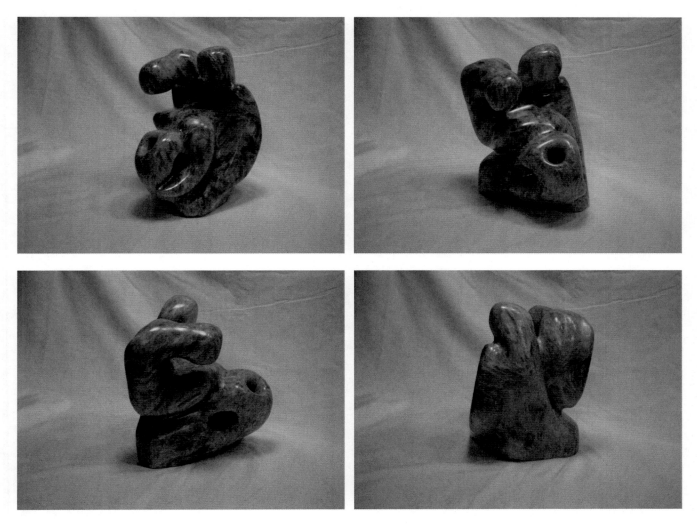

Are you happy with it? Do you like the shapes, the curves, the holes, the angles? Is the finish smooth, complete? Run your fingers over the surface. Is it smooth and velvety, all over? Does it stand upright the way you want it to? Does it sit level and stable? Is there anything you'd like to change? Anything you'd like to add... or remove? Does it look like something you can be proud of having created? If you're happy, then....

Congratulations. You have now completed your masterpiece. Your raw stone has been selected, imaged, shaped, carved, sanded, polished and signed. It is now ready for display and admiration. By the way, have you thought of a title yet? Perhaps something to suggest what you see, but not impose too strong a direction. How about..... 'Namaste'

I like titles which hint, but do not insist, on a possible interpretation. 'Namaste' is a word commonly used in India, when greeting or leaving another person, often accompanied with a shallow bow, hands pressed together in front of the chest. It's meaning is a bit varied, ranging from 'I bow to you' or 'I honor you' to 'the divinity/spirituality in me bows to the divinity/spirituality in you'. Every yoga class I've attended used the term as a greeting between the students and teacher, and again to end the session, as a salutation and farewell. Thus it suggests the yoga poses, without actually referring to them, allowing the viewer to pick up on the reference, or not, as they like. Viewers like pieces to have titles, and also like to have a little explanation of the piece... what inspired it, or how it came to be. Feel free to get creative and poetic, or not, as you prefer.

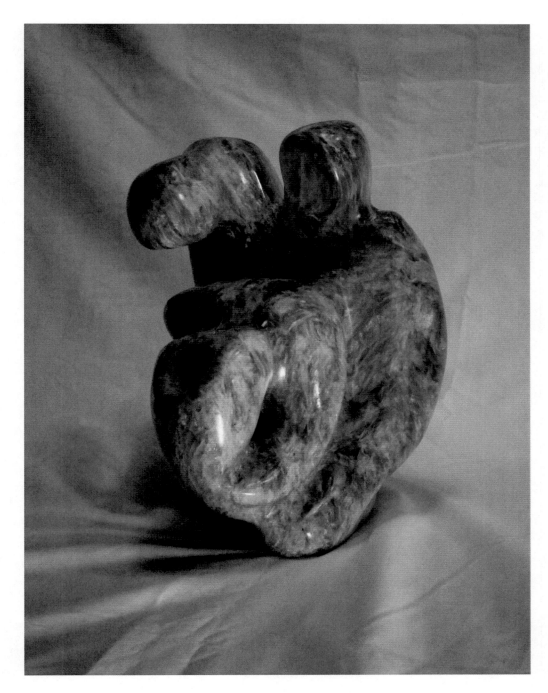

'Namaste'

Link to video: *http://soapstone1.stephencnorton.com/home/finished*

Chapter 14 - Using the Cut-Off Pieces

When you cut away chunks of stone to release your image, the pieces can be small, hand sized or sometimes larger. What can you do with the pieces, other than add them to the pile in your garden? Here's a few ideas.

Smooth down the pieces, making them into a shape and size that fits comfortably into your hand. Sand, polish and oil them. This works best on harder stones that give a nice smooth finish and gleam nicely when oiled, especially if they have lots of color patterning. Slip one into your pocket, and next time the work place gets too annoying, take out your stone and rub it gently between your fingers. The warmth and the silky touch of the stone will calm you. The luster will please your eyes. If the stone is highly patterned, you can trace the patterns with eye and finger, marvel at the beauty. The office annoyances will go away. Maybe give one to your boss......, maybe he or she will go away.

Take the smaller pieces and run the Chaos Method on them. Try the Mystical, simply round them out, accentuate curves, hollows, dips. Maybe drop in a hole. See what emerges.

Chaos

Mystical

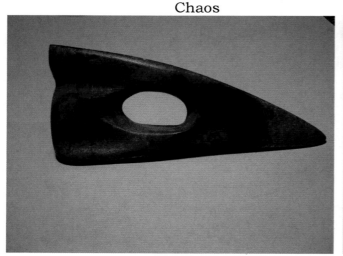

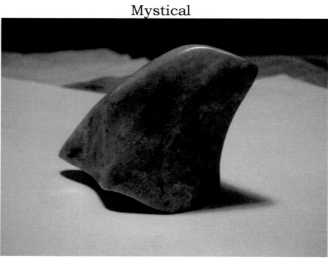

Alternatively, with a bit more work, you can build a statue. My favorite, and admittedly a common image, is the Inuit Inukshuk, which means "in the likeness of a human". Take several pieces of stone, either all of the same color, texture and pattern, or pieces from several different stones. Shape them into arms, legs, bodies, and pieces thereof, or simply select pieces that could fulfill those shapes. Sand, polish and oil them. Now assemble them. Drill fine holes through the pieces and use stiff wire, or even common nails with the head and spike removed, to mount the pieces together, using the wire / nail as the retaining pin. Once the pieces are all drilled and wired to meet your design, add a little epoxy glue to each wire and assemble the completed Inukshuk. Make sure you don't drip the glue on any surfaces that will be visible.

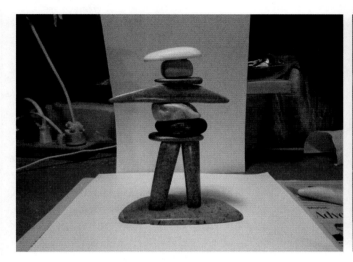 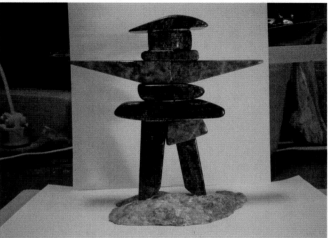

For stability, mount the entire Inukshuk on another piece of soapstone, again using wire / nail and epoxy glue to hold everything in place. Now you have a finished piece. Much nicer than simply throwing the little pieces away. Only downside is you need a fair number of pieces to build the Inukshuk. I won't go into any more detail on the process of wiring and gluing as it's really beyond the scope of this introductory book, but it is covered in depth in Volume Two - Advanced Techniques.

The possibilities aren't endless, but there's lots there. Be creative, think out-side the box, get random, add chaos, listen to that mystical voice. See what you can do.

Chapter 15 - Care and Repair

Soapstone is a relatively soft material, and thus it's fairly easy to damage it. Banging the stone against a shelf as you move the piece can result in a mark on the stone, so be careful when handling carvings. Dust it occasionally with a soft cloth or duster. If it starts to get a bit dull, give it a good polish with a clean, dry, chamois cloth. If you finished the piece with Tung Oil you should not need to re-oil it, but you can if you want. Use the same process as you did when finishing the stone. If you finished the piece with some other oil or polish, such as shoe polish, the shine will go dull over time, and you will need to apply additional coats of polish. Shoe polish is especially prone to going dull. If you used varnish, simply polish the stone with a chamois.

If the stone does get scratched or bruised from bumping, it can be fixed by repeating the last few steps of finishing. Use wet sandpaper of 300 grit or higher, and gently sand out the scratch. If the scratch is shallow, you may be able to start the repair with 600 grit paper. If the scratch is deep, or the stone is bruised and the bruise has produced an area of soft stone, you can cut it out with a small, sharp, chisel. Realize that removing stone to remove the bruise will change the shape of the piece slightly, but usually a carefully blended-in dimple in the stone is not seen as a flaw. Sand till the scratch is gone, moving from 300 to 400, 600, 800 or higher grit paper. One thing to watch for; if you finished the stone originally with 800 grit paper, your repair work must go up to 800 grit paper. If you only finish the repair to 400 or 600 grit, it will have a slightly different appearance when you apply the Tung Oil, and thus will look like it's been repaired.

It's usually easier to see the scratches when the stone is dry, so when you work on a scratch, only wet out the area you're working on. Then move on to the next scratch or bruise.

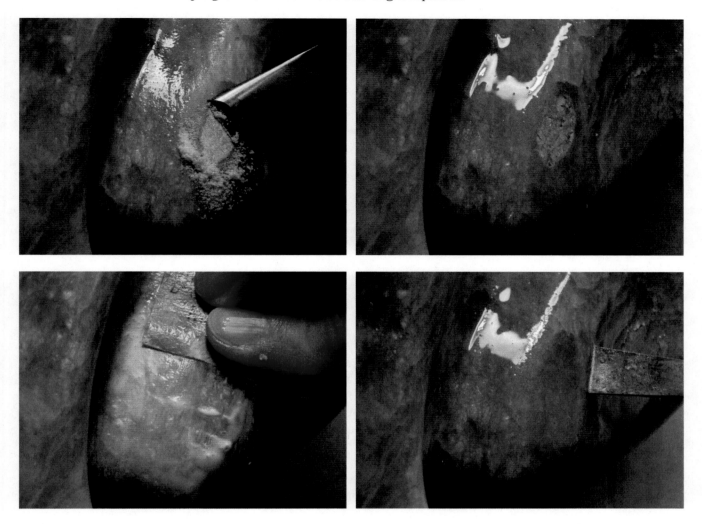

Remove any other scratches, bruises, etc. in the same way. If there are a lot of damaged spots you may want to give the entire piece another overall sand / polish using 800 or higher grit. Wet the entire piece and review for any scratches you may have missed. Leave the piece to dry and then review it again. Remember that the stone looks different dry and wet, and some marks show up more clearly dry than they do wet, and vice versa.

Once the repair sanding is complete, let the piece dry overnight, or longer. Give it a quick polish with a chamois or lint free cloth to remove any dust, then apply the Tung Oil to the newly sanded area. Apply 2-3 coats of oil, letting the piece dry overnight between coats, and polishing the entire piece before applying the next coat. The repaired area(s) should blend into the stone and become invisible. If it remains visible, try using a finer grit sandpaper on the repaired areas. I use Tung Oil because it allows small repairs like this to be made easily and quickly. As mentioned earlier, if you use a hard varnish to finish the piece, and it gets damaged, you almost always have to sand the entire piece to remove the varnish, otherwise the repaired area will be noticeable where the new varnish overlaps the old. Varnish does provide a little more protection than Tung Oil, because it dries with a harder finished surface, but it makes minor repairs much more difficult.

Once the oil is dry, give the entire piece a good polish with a soft chamois, and put it back on display.

Chapter 16 - Documenting the Journey

When I first started carving , I simply picked a stone and started carving. I never took any pictures until I actually put the piece up for sale. I ended up with pictures of finished pieces, but nothing about the journey.

Since then, I've started to keep track of the progress, as well as the end result. As a wise woman once said, 'it's the journey that is important, not the arrival' (or something along those lines). I do find that it is the journey, the encountering of obstacles and finding the solutions, that I enjoy the most. The end result is nice, and I enjoy looking at a finished piece, admiring the shape, color and finish. But then it's done. Fixed. Static. Time to find another chunk of stone and start a new journey.

So, before you actually start hacking away at your stone, stop and think for a moment. Ask yourself if you want to record the journey. If your answer is no, then by all means, start hacking.

If your answer is yes, then get out your camera and take a few pictures. At least a couple of the original stone, before you start doing anything to it. How many pictures you take between start and finish is entirely up to you. Maybe just a before and after pair. Maybe take several pictures after each work session. As this book demonstrates, you can make a very detailed record of the journey. Compare the book to the couple of photos of the Crows Head Tulip shown in the next chapter. One record is very complete, the other almost nothing more than before and after. See which you would prefer for your own journey.

If you do take regular pictures, take several views, sides, back, front, top. Digital cameras mean taking the pictures doesn't cost anything. Take lots, throw them on your computer and decide later if they're worth keeping once you've finished the piece. If your camera takes video, walk around your piece at the end of each work session and take a movie. Or, if you made yourself a Lazy Susan, stand the piece on the platform and turn it slowly while taking the movie. When you're done, string all the images, stills and movies, together and make a continuous movie of the stone as it changes shape. Remember to always walk around in the same direction, or turn the Lazy Susan in the same direction, otherwise the compilation doesn't work as well. Though I guess if you alternated directions at each step that would work too. Be creative.

Twenty years from now, you, or your kids, or your grandkids, will get a kick out of watching your piece of dull, dusty stone morph into a finished piece in all its glory.

Congratulations on having completed your journey in stone. I hope the book was useful and helpful to you, and that you enjoyed the journey. Display your piece with pride. You've done a great job. Now, go get another chunk of stone and start another journey.

Chapter 17 - Examples of Other Pieces

Here are some examples of other pieces. All pieces are finished with Tung Oil and polished.

Crows Head Tulip

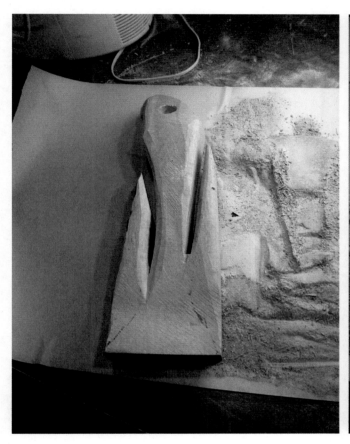 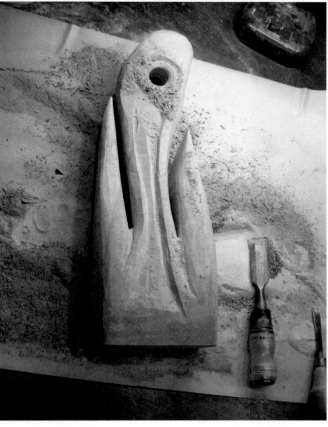

Early stage, just cut in the side ... wings? leaves? with the hacksaw, with the blade set sideways. Drawn in some guidelines to see what it would look like if I extended the wings down towards the base. Crows Head was a Chaos Method piece to start, but the piece soon took on a life of it's own, and thus became a Mystical piece. The name for the piece didn't really appear until almost the end of the journey. Notice how much more interesting the side with the grooves looks (on the right above), compared to the side with no grooves (on the left). Soapstone loves grooves and curves.

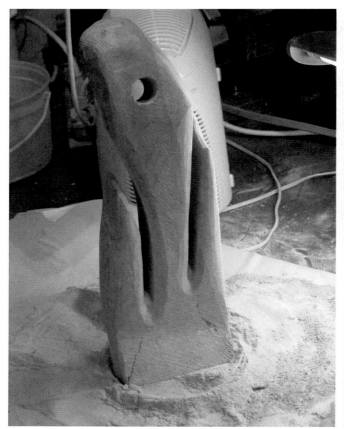 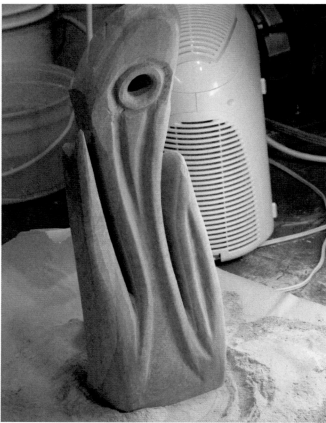

Check for stability of the base, make sure it sits flat and stable, make sure the height doesn't make it subject to falling over easily. Once the base is firm, start to add in grooves and hollows to give character and add some drama to the piece. The eye is a hole, and we can't remove it now, so let's accentuate it, give it definite character and place. The grooves are cut in with a chisel, shaped and then sanded into a smooth round, using the same process we used in the book to cut in a shoulder.

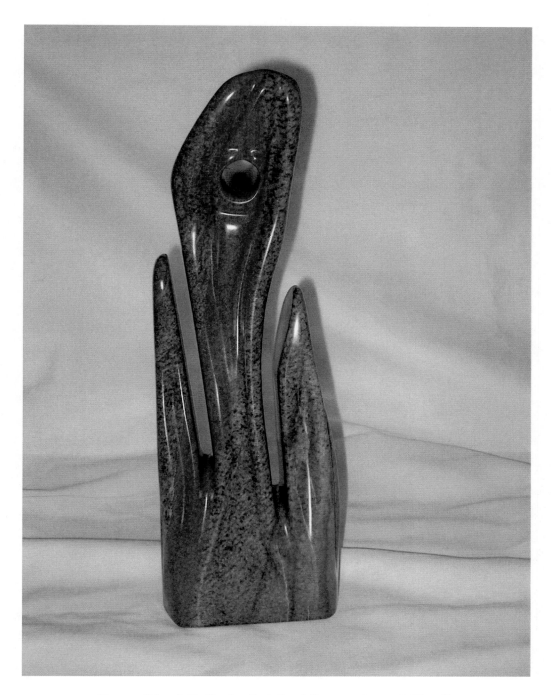

Crows Head Tulip in finished form, about 16" tall.

African Woman's Head

This was a MYSTICAL piece. I simply smoothed the stone to begin, and then followed the image as it was slowly released from the stone. One side shows a youthful young maiden, clear skin, unblemished. The other side shows the same woman at the end of her life, face reflecting age, experience, exposure to sun, wind and weather, yet still strong and unbowed. The piece is about 10" tall.

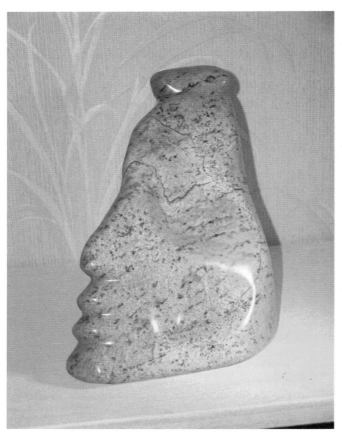

Young face

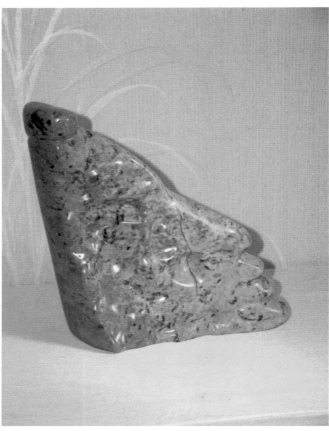

Old face

Aztec Eye of God

This was the first piece I did where the Aztec feel came into effect, almost of it's own accord. I've since done several other pieces with an Aztec look and feel, and I think it's becoming my favorite motif (along with all my other favorite motifs....). It's about 12" long, 6" high.

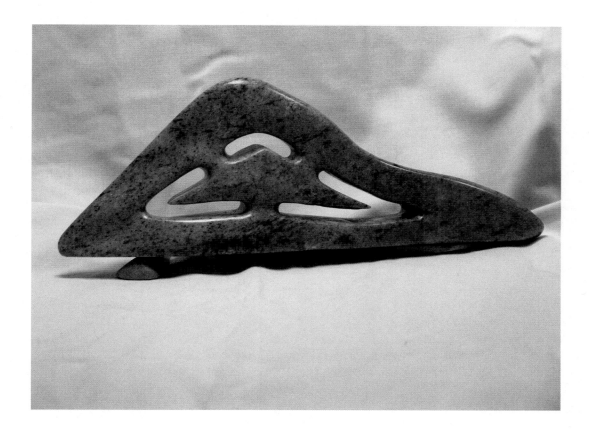

Baby Grey Whale

This was a RATIONAL piece, where I imposed my image onto the stone. The whale shape was sketched several times, and measurements taken to keep the correct body shape, size and perspective. A few minor flaws were left in the stone to suggest the natural roughness of the whales skin. Once finished, it was mounted on a different colored stone, which was left fairly raw and unshaped, to give the feel of sea waves rolling under the whale. The base, while left as almost raw stone, still received 4 coats of Tung Oil, to bring it's look into synch with the whales body.

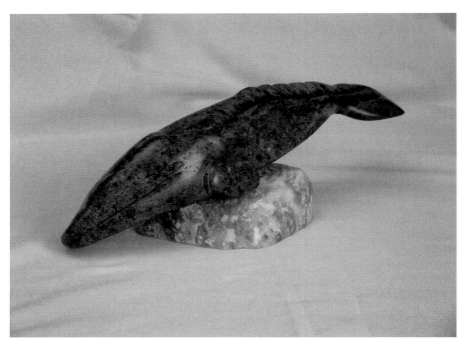

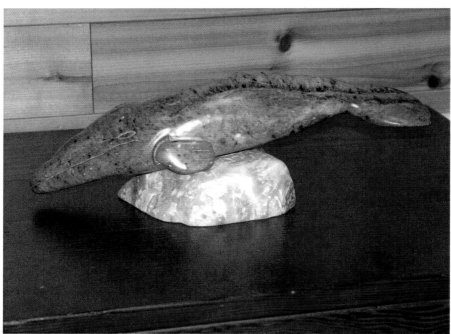

White Sperm Whale

This was done using a very soft, 'buttery', white stone. It carved beautifully, just like butter with a hot sharp knife. The final polish is soft matte. While soft stone does take some getting used to, it can be used to produce some beautiful pieces. Like all my animals, this was a RATIONAL piece, carefully planned, using sketches and measurements. It's about 14" nose to tail, and sits on a chunk of the raw white stone. It's one of my favorites, and stays in my private collection.

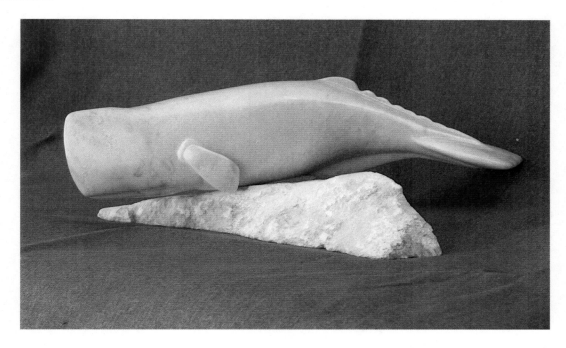

Grasses in the Wind

One of my early 'large' pieces, again a Rational piece. This was cut from a single 50 lb block of pale green stone, with only a little color pattern. The focus was on depicting grasses as they blow in the wind, and how they don't always all blow in the same direction, suggesting the bigger prairie field, swaying in many different directions. Notice the stone left in a near-raw state along the base, suggesting the soil around the roots of the grasses. Stands about 18" high.

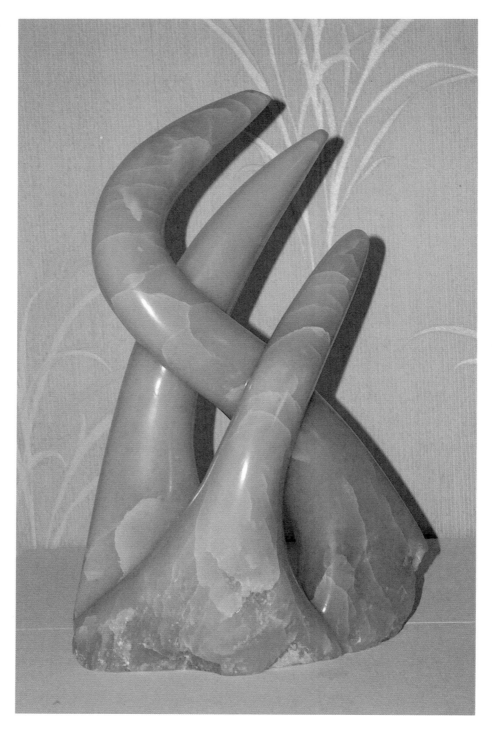

Notes from the Author

Thank you for reading my book. I hope you enjoyed it and hope you find it helpful in creating your own soapstone masterpieces.

~~~~

For access to my other books, or to send comments, please contact me at my web site:

**www.StephenCNorton.com**
or
**email: comment@stephencnorton.com**

~~~~

This book was published by
Northwind Ink
Victoria BC
Canada

www.NorthwindInk.com

email: publish@northwindink.com

Northwind Ink is a small Canadian publishing house, specializing in small run editions while providing access to global sales via Amazon, Apple iTunes, Barnes & Noble, Kobo and other on-line distributers. We support new authors in most genres and those looking to publish their own memoirs. Our aim is to keep costs to the author as low as possible, while still producing a quality publication. We produce books both you and we can be proud of.

If you wish to have your book published by NorthwindInk feel free to email me.

Made in the USA
Las Vegas, NV
11 January 2023

65429245R00067